Lessons on
Figure Drawing

J. Leonard Watson

DOVER PUBLICATIONS, INC.
Mineola, New York

Bibliographical Note

This Dover edition, first published in 2007, is an unabridged republication of Chapters 7 and 8 from Volume 6 of the I.C.S. Reference Library, originally published by the International Textbook Company, Scranton, Pennsylvania, in 1905. The three-page foldout on page 72 in the 1905 volume is in the same location, but on three consecutive pages for the Dover reprint.

International Standard Book Number: 0-486-45463-0

Manufactured in the United States of America
Dover Publications, Inc., 31 East 2nd Street, Mineola, N.Y. 11501

ELEMENTS OF FIGURE DRAWING

DRAWING FROM THE HUMAN FIGURE

INTRODUCTION

1. Difference Between Life and Cast Drawing.
No one should undertake to make finished drawings from a living model without having first had considerable practice in drawing from the plaster cast. There is no harm, however, in making sketches from the figure that require no longer than 15 or 20 minutes time, if full and proper attention be given to the direction of the lines and the position of the masses. But the student must be familiar with the form of the different parts of the body as they appear in the plaster cast before he can successfully draw from the living model. No matter how steady it may be, the living model will unconsciously change its posture under growing fatigue, and unless familiar with form and construction the student will draw one part of the figure as it first appears and another part as it appears after the model has sagged from fatigue. In drawing from the cast, the main forms and proportions should be closely studied in order that the human form will be so impressed on his mind that the student can rapidly sketch the whole figure before exhaustion has set in, and can promptly detect and eliminate errors in his own work owing to changes in the pose of the model.

2. Posing the Model.—For general practice it is usually better to have the model elevated somewhat from the eye. To accomplish this the model should stand on a box or platform, while the effect of elevation may be still further increased

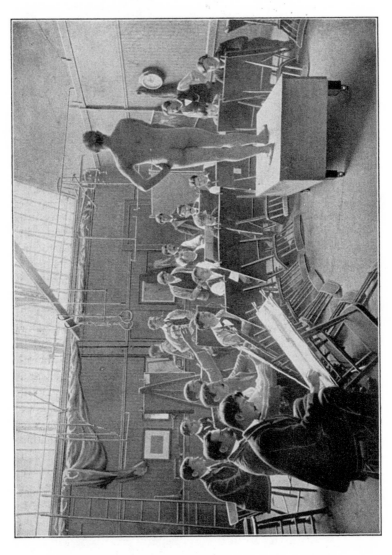

Fig. 1

Fig. 2

by the student working in a sitting posture as low as possible. A convenient easel can be made by inverting an ordinary kitchen chair, as shown in Fig. 1, which is a photograph of the life class of the Art Students' League, of New York, and their usual method of working. The drawing board can thus be laid at a convenient angle upon the rounds of the chair, and at the same time the student can plainly see the model.

MATERIALS USED

3. Crayons and Papers.—Drawings from the figure, as from the cast, may be executed in charcoal or crayon on white charcoal paper, many brands of which can be found in art stores. Two popular brands, the Lalanne and the Michelet, are imported, while the Strathmore paper made in this country is considered quite as good. Errors may be erased by means of a piece of fresh rye bread, as this leaves the surface of the paper in quite as good condition as before the erasure, whereas rubber roughens it. A piece of string, with a weight on the end of it to serve as a plumb-line, is very serviceable in noting the points that fall beneath one another in the figure. This may be held before the eye, as shown in Fig. 2, and various details may be thus recorded to give points from which to work.

4. Stomps.—Where a fine finish is required to the drawing, a pulverized sauce crayon is laid on with small paper

FIG. 3

stomps, Fig. 3, which consist of rolls of cartridge paper of various proportions from the size of an ordinary brush handle to the thickness of the forefinger. From this size, however, to the largest ones they are usually made of chamois leather.

For charcoal work it is best not to use the stomp, as it is more convenient for blocking out and general modeling, but for *close modeling*, as delicate finishing is termed, the lines may be blended into tints by touching them with the stomp, or it may be dipped in the pulverized sauce crayon as one would dip a brush in color and the tints laid on directly with it. In working, one needs a small piece of sandpaper to keep the crayon pointed, and an easel on which the board can rest.

LAYING IN THE FIGURE

5. **Blocking in.**—The first blocking in of the general form of the figure is called **laying in,** and it should cover the whole length of the paper. The reason for this is that when one is required to make compositions either for decorative work or for illustration, each figure must fill a certain space, so that by becoming accustomed to proportioning the size of the drawing to the space it is to fill no difficulty is met with in future work.

6. **Unit of Measurement.**—The head, from the chin to the crown, is commonly used as a unit of measurement, each figure being considered as so many heads high. A pencil held upright at arm's length may be used in estimating the proportions and distances for different parts of the figure, as shown in Fig. 4. In this way it is possible to locate almost exactly the position of each detail of the figure before the main structural lines are boldly drawn in. With the plumb-line to locate points that fall beneath one another and the pencil as a scale for measuring, one can readily locate all the main features with exactness.

The first measurement to take is the height of the head, and with that as a unit, measure the number of heads in length each portion of the body appears to be. The standard human figure is assumed to be eight heads high; that is to say, a man standing 6 feet in height should have a head very close to 9 inches in height. The female head, however, is larger in proportion to the height than the male, and the average woman stands seven and one-half heads

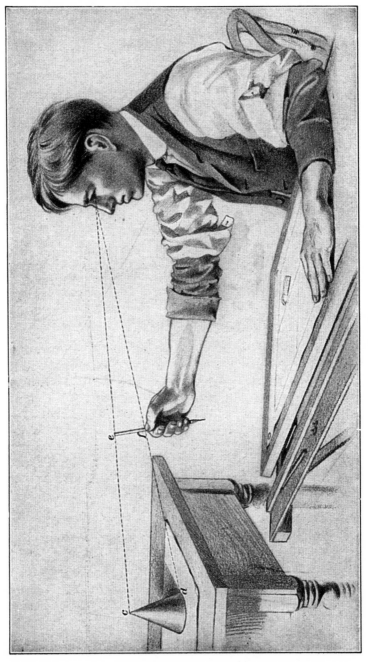

Fig. 4

high. However, various exceptions to these measurements are found in every-day practice, as will be pointed out as we proceed.

7. Action.—In viewing the figure, the first thing to consider is the **action**, by which is meant the general trend of the main lines. By these main lines alone it is possible to express the entire intention and purpose of the figure. One readily sees that a man running leans forward, that a man pulling on a rope and bracing himself leans backward, and that a man standing in conversation usually rests on one foot so that the main lines of the body are perpendicular. The direction of these lines expresses the action of the figure and should always be considered first. This combined with the proportion of the main forms gives a solid ground on which to proceed with the work.

The lines indicating action and proportion should be marked by definite points of start and finish, and should be drawn in boldly without any attempt to closely follow the general contour. By *definite points* are meant the shoulders, hips, knees, ankles, etc., which, being located by means of the pencil measurement lines, can be drawn from them in bold sweeps giving the outlines of the main construction. These lines will give the action; the lines of proportion can be worked over them. By combining these the first necessary steps in the drawing of a well-constructed figure are taken. In drawing the arm, work from the point of the shoulder to the elbow, from the elbow to the wrist, and from the wrist to the tips of the fingers; this will give to each form its proper allowance of space and distance, and the subtle curvature of line that must afterwards be expressed is built up on it, but should never be attempted until the first crude drawing is satisfactory and as nearly correct as possible.

While great stress is laid on these details in drawing the human figure, they are equally important in the drawing of any object; but as the human figure is the most difficult of all objects to express, no detail of these rules can possibly

be overlooked. All estimates of proportion are more or less dependent on the point of view from which the student works, and a figure though it measure eight heads in height would appear more if the eye of the worker were below it, as would be the case if the model were on a platform. Thus, a drawing should always be made as it appears under the influences of different circumstances.

8. Median Line.—The number of heads in height being established, a central point of the figure is next to be found. If the view happens to be full front or nearly so, a **median**, or **central, line** can be drawn from the pit of the throat, between the breasts, to the navel; this will denote the main trend of the trunk and be of great help in finding the proportion that the shoulders, breasts, arms, and sides bear to each other. It is always best to draw the figure around a strong central construction, as this is much easier than attempting to draw an outline and filling in the other portions afterwards.　　————

FORESHORTENING

9. Foreshortening is the term applied to the representation of an object on a plane surface in perspective drawing. It is a well-known fact that if we look squarely at the surface of a circle every point of it is equally distant from the center, but if it is inclined from us its perspective becomes an ellipse that varies in width according to the angle of inclination. This narrowing of a dimension is called foreshortening, and an ellipse drawn or painted to represent a wheel or other circular form in perspective conveys to the mind the idea of a circle, because the eye is accustomed to seeing circles in that shape when they occupy that supposed position.

Foreshortening is also expressed by means of a change in size, distant and near objects being represented as differing in size according to the varying distances from the eye. It should be borne in mind, however, that the relative difference in size between two objects, one more distant than the other, is dependent not on the distance that they are apart, but on the relative distance that each is from the eye. For

instance, a circle 2 feet in diameter and 20 feet from the eye will appear only one-fourth the size of a circle 2 feet in diameter and 10 feet from the eye. In this case the circles are 10 feet apart. If, however, they are moved backwards a distance of 100 feet and still maintained at a distance of 10 feet apart, one of them being 110 feet from the eye and the other 120, their apparent difference in size will be very slight, as their relative distances from the eye will not differ so widely. In the same way when drawing the human figure, it should be borne in mind that distant portions of the figure, though they appear smaller on account of their remoteness from the eye, must not be exaggerated in their diminution; otherwise, the figure will possess a distorted appearance unless viewed from exactly the same point from which it was drawn.

10. In the foreshortening of the human head that must be made when the student is located so that he looks up and under the chin and other features, the effect will be much the same as though the head were thrown sharply backwards and he stood directly in front of the figure. This is illustrated in Fig. 7. The space between the eyebrows and the lids is brought into full view, because none of it is lost in perspective as is the case when the eyes of the model and the eyes of the student are on the same level. Here also one sees the nostrils and beneath them the triangular mass of shadow that suggests the general formation of the base of the nose. The upper lip is observable at its greatest thickness, while the lower lip appears thinner than it would if the eyes were on a level with those of the model. The surface beneath the jaw is also distinctly seen, and one becomes conscious that the chin is more in the foreground than any other part of the face. The ear is also dropped below the level of the eye.

If the head and face were geometrical in form, like a cube or cylinder, their foreshortening could be accomplished with mathematical precision by means of mathematical perspective, but the surfaces of the head and face are complex, and

in consequence cannot be governed by any simple rule of perspective. The eye must be the sole judge.

When the head is observed in three-quarter view and from a point below the model, the features (or details of the features) nearer the eye of the worker appear higher than those that are farther removed; and, on the contrary, when the three-quarter view of the head is seen from a point above the model the features (or parts of the features), nearer the eye of the student appear lower than those that are farther removed.

In drawing a head that is much foreshortened, it is well to grasp points of prominence on which to build the construction, such as the temples, cheek bones, point of the nose, chin, and ears. The line from one temple to the other will suggest the main direction of the forehead, from the temple to the top of the ear another main direction, from the cheek bones to the chin and the chin to the bottom of the ear still other directions.

When the head is seen from a point far above the model, the whole top of the model's head is brought into view; the eyes are lost beneath the brows, their whereabouts being suggested only by shadows, and the lower part of the nose overhangs the upper lip, throwing it into shadow. From this standpoint the upper lip appears to be very thin and the under lip is exposed to view at its full thickness. The under surface of the jaw is completely obscured and the position of the ear is very high. The position of every feature, or part of feature, is exactly the reverse of what it would have been if seen from a very low point of view.

MODELING

11. The term **modeling,** as applied to drawing and painting, expresses the idea of form and solidity through the medium of light and shade. A well-constructed figure even though drawn only in outline will suggest solidity, but modeling makes it a tangible mass. If a figure is placed in strong light coming from one direction, the light and shade

will resolve themselves into well-defined planes, while the margins of the shadows will seem to have a definite outline, darker in some places than the body of the shadow itself. We speak of planes of light and shade, as that is the most convenient way of expressing these details.

We assume, to start with, that the body is composed of a number of flat or flattened surfaces joined together to cover the general mass in the same manner as the block head and the block hand. The blending of the shadows where these planes meet gives the rotundity and completes the modeling of the figure. The simple effect of light-and-shade study in the block head and hand are perfectly applicable here, and though the shadows may not be sharply defined they may be considered so and blended off afterwards. In figure drawing, the eye must search carefully for half tones of shadow that are not seen in the block cast, in order to express them in their proper value.

In drawing from the figure the first thought should be to search for the definite margins of the main shadows; accents that are strong in some portions of the margins are lost in others, and in other places the margins of the shadows appear to blend with the lights forming the half tones. Careful search, however, will disclose the fact that the half tone itself has a definite margin. Looking at the figure as a whole, search for three different planes of tone—the full light, the full shadow, and the half tone. With practice it is possible to distinguish and draw the margins of these three tones accurately and then to lay in the tones themselves. Thus, the effect of solidity is certain, because the blending of one tone with another is a very simple matter. There is a danger, however, that even when these three tones are correctly drawn, there will be a certain harshness and want of sympathy in the treatment of the shadows.

As these tones have been worked in mechanically the figure lacks the softness and lifelike appearance that it possesses in nature. We must give to these shadows, therefore, that infinite variety that they really possess. Searching the planes once more, places on the margin of the shadows are

found where the definition is entirely lost, the shadow melts entirely into the light; in other places, the definition is accented by a greater depth of tone and a more distinct edge. This search for variety in the quality of the shadow should be made after the main tones are rendered, because it is very hard to discern and is liable to detract from the character of the work if an attempt is made to render them as the general modeling proceeds.

ANALYTIC STUDY OF THE HUMAN FIGURE

THE HEAD

12. Profile View.—Viewed in profile, the head may be enclosed in a perfect square and the face divided into thirds

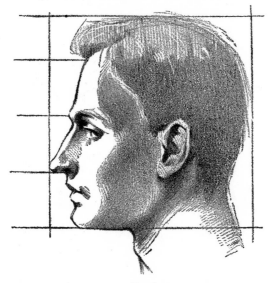

Fig. 5

from the roots of the hair to the chin, as shown in Fig. 5. These thirds may be marked: *1*, from the roots of the hair to the brows; *2*, from the brows to the base of the nose; and *3*, from the base of the nose to the bottom of the chin. The

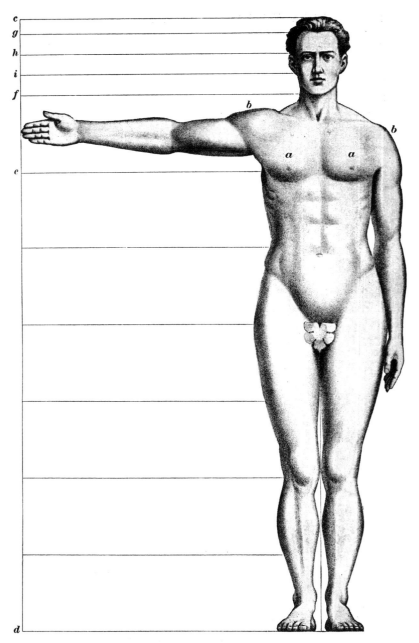

FIG. 6

distance from the crown of the head to the roots of the hair is one-fifth the height of the head. These measurements vary with each individual and cannot be taken absolutely, but for general drawing may be considered as a basis for construction.

13. Full View.—In the front, or full-face, view, the head may be considered as five eyes in width, the space

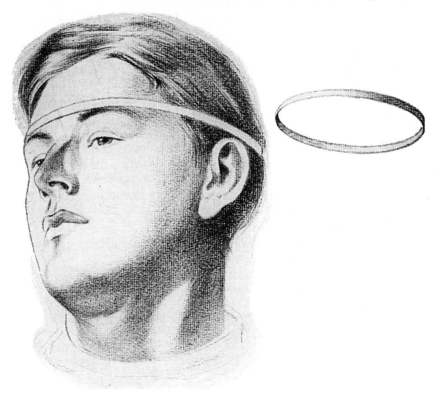

FIG. 7

between the eyes and on each side occupying a distance equal to the length of the eye itself, Fig. 6. If a cross-section of the head were made at the height of the eyebrows, it would be nearly oval in shape with the fulness in the back; the ordinary band of a hat illustrates this. If a piece of tape

be tied around the head at the line of the brows so that it touches the tip of the ears it will describe an oval and form a means of locating certain features of the face when the head is thrown backwards or forwards so as to change the relative position of the features, as shown in Fig. 7. Thus, in drawing the head from any standpoint, whether the eye is far beneath, looking up to the model, or above, looking down on him, the brows and tips of the ears will always follow this oval strip, or tape, and can always be accurately located. However, the human head is so varied in proportion that it must be drawn as seen irrespective of any set rules, for adherence to them is likely to be productive of a stock face or figure that soon becomes devoid of interest and novelty.

THE NECK AND SHOULDERS

14. After the placing of the head, the neck and shoulders must be considered; a line from the point of one shoulder to the point of the other gives the general direction. Where the neck joins the back of the head it rises much higher than at its junction with the fleshy part of the face under the jaw, but the junction of the neck with the back at the line of the shoulders is correspondingly higher than its junction at the pit of the throat. Thus, the column of the neck has a downward, oblique direction from its

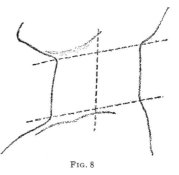

FIG. 8

points of junction in the back to its points of junction in the front part of the body, as shown in Fig. 8.

The shoulders, which in the common acceptance of the word include all the space from the neck to the muscle that caps the end of the bone of the upper arm (usually termed the humerus), rise above the clavicles, or collar bones, and form a sort of muscular defense for them.

THE MUSCLES OF THE BREAST AND ABDOMEN

15. The Pectoral Muscles.—The two rather massive prominences on the breast of the male figure shown at *a*, Fig. 6, and *b*, Fig. 9, are the pectoral muscles. They are separated by a slight indentation or hollow extending from the pit of the throat downward. In repose their surface is unbroken by any muscular markings, but under strong action they are well defined. Their contour is indicated by the shape of the shadows that fall on them. The various forms on the chest are very readily located by the relative positions of the nipples, which in the standard male figure are one head below the chin, as shown in Fig. 6.

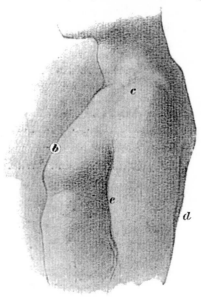

FIG. 9

16. Muscles of the Abdomen.—Beneath the massive pectoral muscles, on each side of a perpendicular line to the pubes, are the muscles of the abdomen. These also are somewhat indistinct when in repose, and are frequently obliterated entirely by an excess of fat. In the thin or muscular figure they are sharply defined when in action and appear as three separate masses on each side of a median line from the base of the pectoral muscles to the pubes.

17. The Breasts.—In drawing the breasts of a female figure, the forms and shadows are very subtle. In the front view (see Fig. 25) where there are no contouring outlines, the expression of these details depends entirely on the careful

rendering of the marginal shadows and the correct estimate of their proper tones. The position of the nipples and their relative position to the navel should be accurately determined, as these three points are of primary importance in the construction of the torso, or trunk, of the figure.

THE SHOULDER, ARM, AND HAND

18. The Humerus, Ulna, and Radius.—In the upper part of the arm there is a single large bone called the humerus. At its upper extremity it joins the shoulder, and at its lower extremity it unites with two smaller bones, called the ulna and the radius, and forms the elbow. The ulna and the radius unite at the wrist with several smaller bones that extend to the joints of the fingers. In the construction of the forearm, as the lower portion of the arm is called, the radius is on the side of the arm that connects with the thumb, while the ulna is on the side that connects with the little finger.

19. The Deltoid Muscle, and the Biceps and Triceps.—Over the shoulder joint where the humerus connects with the clavicle is stretched the deltoid muscle, which caps the shoulder like an epaulet, as shown at *c*, Fig. 9, and *b*, Fig. 6. The biceps muscle *e*, Fig. 9, which is that one made prominent in the front of the upper arm, is forwards of the humerus, and the triceps muscle *d*, corresponding with it on the back of the arm, is on the opposite side. Thus, the upper arm is deeper than it is wide owing to the fact that these two muscles lie on opposite sides of the bone, and its greatest dimension is seen when viewed from the side.

20. Pronation and Supination.—When the arm is in the act of **pronation,** that is, in the position shown in Fig. 10, the muscles of the forearm assume a widely different appearance from that seen when the arm is in the act of **supination,** as shown in Fig. 11. During pronation the position of the bone of the forearm is distinctly seen by the shadow that runs to the point of the elbow. During supination the bone is not seen, and the shadow shown is under the

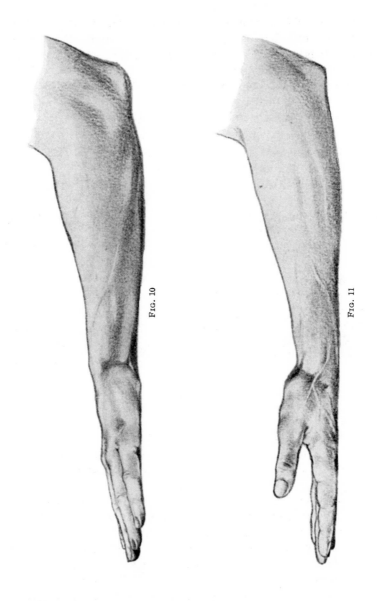

Fig. 10

Fig. 11

muscle. The contours on the upper and lower lines are changed completely, especially about the wrist. Familiarity with these forms is only reached through long practice in drawing from the figure and close observation. Therefore, the details of the arm in both these attitudes should be carefully studied so that the memory will be stamped with the difference in the contours of the muscles. In pronation, the forearm has reached what is practically its extreme limit of range in one direction, and in supination it has reached the extreme limit in another direction. There are varieties of action between these two extremes that change the position of the muscles to such an extent that one must be thoroughly familiar with them in order to have the arm in good drawing, no matter in what position it may be.

21. The Arm.—In Fig. 12 is shown the male arm as seen from a low point of view, in consequence of which it is considerably foreshortened. The shoulder cap, or deltoid muscle, here becomes clearly defined, and the muscles of the forearm are shown rigid and full near the elbow owing to the fist being clenched. The shadow on the inside of the arm indicates the intersections of the planes that give the contour in this position.

In Fig. 13 the female arm is shown with a clenched fist. By being drawn up tight against the upper arm, the forearm is given a fulness near the elbow that is seen in no other position. The characteristic smoothness of the female arm is also shown. Even in this position the muscles are not knotty and hard as in the male arm, but the curves round off gracefully, one into the other, forming gentle undulations rather than sharp, emphatic curves. This is a characteristic that distinguishes all of the contours in the female figure from similar contours in the male figure.

Fig. 14 shows a muscular arm of the male figure, the development of which is clearly shown. The deltoid muscle of the shoulder can be seen reaching like an epaulet from the top of the shoulder to the side of the arm and entering it in a blunt point between the biceps muscle and the triceps.

The triceps bulges slightly at the back of the arm, but its
fullest part is nearer the shoulder than the nearest part of

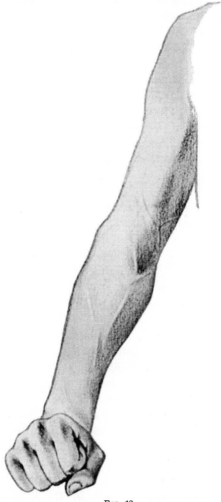

FIG. 12

the biceps. The muscles of the forearm are emphasized, as
in Fig. 12, by the clenching of the fist, but if the hand were
gradually opened the muscles on each side of the forearm

would gradually flatten out and the fulness of the forearm spread somewhat toward the wrist.

Fig. 15 shows the male arm in a relaxed state, but the muscular development is sufficient for one to observe the power contained therein. Down the full length of the arm the plane of shadow indicates the shape of the muscular forms beneath the skin and follows

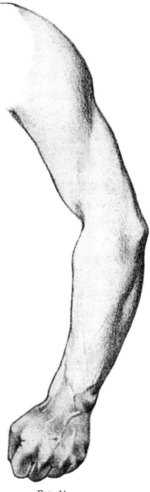

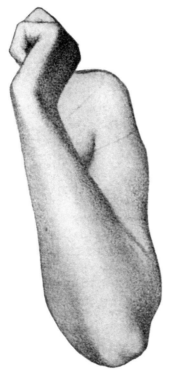

FIG. 13 FIG. 14

each concavity or convexity of surface on the side away from the light. The position of the elbow becomes marked by a sharp angle in the shadow, while on the back of the hand

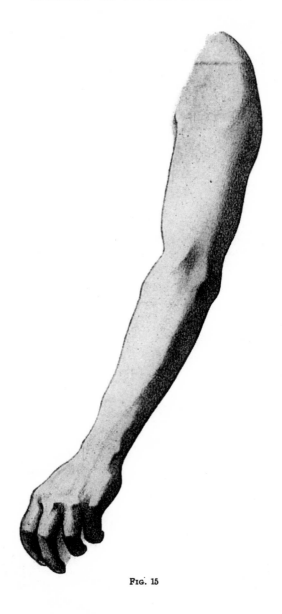

FIG. 15

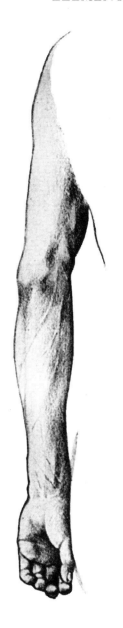
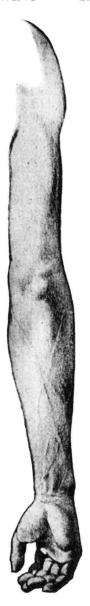

FIG. 16

each knuckle and joint is expressed by a modeling of small planes of light and shade.　This illustration will bear careful study; the prominent bone on the outside of the wrist and each of the joints of the fingers are expressed by a little plane of light located in just the right place.

Fig. 16 shows the construction of the arms and location of the planes of light and shade, when these members are seen from behind.　The muscular development is slight and the position one of complete inaction and listlessness.　The feeling of inaction is expressed by the flatness of the muscles and the evenness of the curves from one plane to another. Note the creases and folds in the skin that give character to the elbows and also to the expression of the ligaments in the wrist as they run from the muscles of the forearms to the fingers.　Though none of the muscles are contracted, the plane of shadow on the inside of the left arm shows all the gradations of bone structure and muscle, and in many cases will even indicate the form, branching, and general distribution of the veins.　In the right arm note particularly the thin appearance of the upper part; this is due to the fact that the biceps and triceps are set one before the other with the bone between them, so that the smallest dimension of this portion of the arm is shown.　But the position of the forearm is such that the bones and accompanying muscles are seen from their widest standpoint.　The relative widths and positions of the various proportions of the arms as they are turned in different positions should be carefully studied.

In Fig. 17 is shown a profile view of the female right arm. The upper arm appears rather short for the forearm owing to the fact that when making this drawing the model was placed far above the eye.　This foreshortening gives the effect of elevation to the figure.　The left arm resting upon the small of the back shows the smooth, graceful curves of the outside line of the female arm in this position, contrasted with the sturdy and abruptly changing planes of the male arm.　In both the left and right arms the unbroken smoothness of line characteristic of the female figure is strongly illustrated.

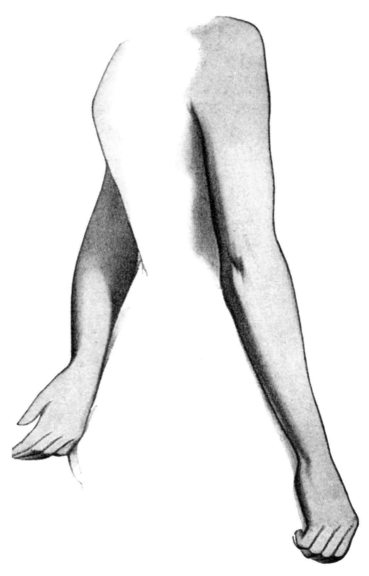

FIG. 17

In Fig. 18 the thin, undeveloped arms of a young girl are shown. Here the chief interest centers in the fore-shortening of the forearms and of the hands. In the model's right arm the wrist is entirely hidden, and unless the arm and elbow, as seen to the left and below it, are properly rendered the unity between the hand and the arm will not be expressed. This should be very carefully

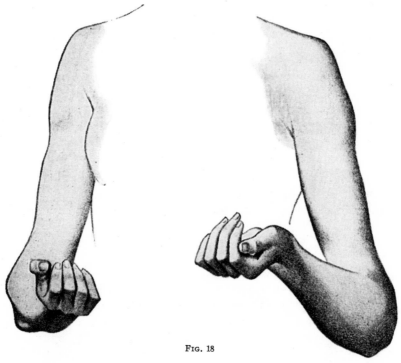

Fig. 18

studied. In the model's left arm nothing is hidden, but the foreshortening must be carefully studied and the work must be very accurate. In this position the hands appear larger than they would ordinarily, as they are from 8 inches to 12 inches nearer the eye than the elbow. No set rule can be given for this foreshortening, but attention must be given to the proportions of all the parts in order that the fore-shortening may be expressive of existing conditions.

22. The Hand.—The appearance of the hand is so influenced by perspective in all positions that actual measurements of its proportions are of little value. The forefinger and the third finger are usually of about the same length, and the distance from the knuckles of the forefinger to the joint of the wrist is approximately the same as the distance from the knuckles to the tip of the finger. The middle finger is longer than those next to it, and the little finger is the shortest of the four.

The characteristics of the hand naturally vary with the individual. In the clenched fist the forms are very similar to those of a plain block hand, and in drawing details of the hand the same rules apply as in drawing the head or other parts of the figure. The mind and eye seize on prominent points for starting and finishing lines. These points vary with the position of the hand, but generally speaking, the wrist, knuckles, and first and second joints of the fingers and thumb are to be located first and the construction built around them; close drawing of the contours may then follow. The shadows should be carefully modeled so that their margins will be well defined, as the solidity of appearance is dependent entirely on the accuracy with which these shadows are handled.

THE THIGH

23. Location of the Principal Muscles.—In studying the thigh it is well to know where certain muscles are placed, although this member is usually so covered with fat that it is difficult to find lines of separation between the various sets of muscles. When the thigh is made rigid by strong action it will be seen that on the outside of the upper part of the thigh there is a large muscular prominence that forms a ridge that extends obliquely across the leg, from *a* to *b*, Fig. 19 (*a*), so that when it reaches a point above the knee it is on the inside of the leg. This ridge is made up of several large muscles, but their origin is difficult to trace on the figure, and consequently in rendering the thigh the eye must carefully search for shadows and their outlines in order that all may be intelligently expressed.

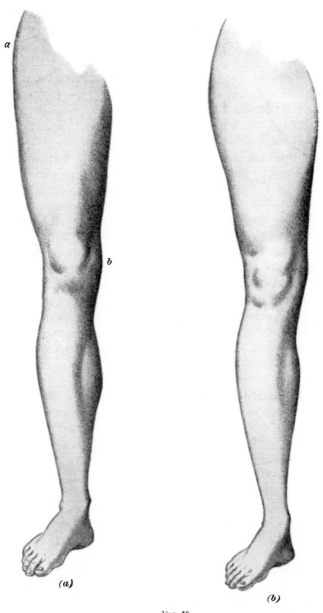

FIG. 19

24. The Biceps of the Leg.—The large muscle on the back of the thigh is known as the biceps of the leg, and has a use similar to that of the biceps of the arm; that is, to draw the lower portion of the leg upwards and toward it. Its prominence is plainly seen when the leg is viewed from the side and gives the thigh, similar to the arm, a greater depth than thickness. The upper bone of the leg is called the femur and unites with two smaller bones in the lower portion of the leg, called the tibia and the fibula.

The thigh of a female is much larger in proportion to the calf than that of the male.

THE LOWER LEG

25. The three principal muscles of the lower leg are the two large ones that form the calf, and a smaller one in front of the shin bone. Viewed from the direct front, the prominence of the calf is very marked. Its most prominent part on the outside of the leg is somewhat higher than its most prominent part on the inside of the leg, as may be seen in Fig. 19. In rising on the ball of the foot these muscles are brought sharply into prominence, and when seen from the back of the leg their form is very clearly defined. The shin muscle is brought into prominence by placing the heel firmly on the floor and drawing the foot upwards as far as possible. In profile, or side view, the shin muscle curves slightly forwards from the bone, and the greatest width of the calf is slightly higher than a point midway between the kneepan and the sole of the foot, as shown in Figs. 20, 21, and 23.

The position of the foot governs the appearance of the muscles of the leg in identically the same manner as the position of the hand governs the muscles of the arm. With every turn of the foot the points of muscular prominence vary.

The muscles on the inside of the leg are seldom so well marked in women as in men, the lines being much straighter on the inside, as a rule, and more curved on the outside. The shaping of the muscles themselves, however, is practically the same, and the difference of appearance between the male and female is due almost entirely to the filling in

of fat. Owing to habitual exercise, due largely to the differ-
ence of amusements among male and female children, the
male muscles become strongly developed and less fat fills in
between them. In the adult's leg the male is characterized
by a development that clearly locates the position of each
muscle, whereas in the female the curves of the leg are
continuous and the delineation of the muscles can be traced
with difficulty.

There is a common tendency in the male figures toward a
separation of the knees giving a bow-legged appearance,
while in the female figure the tendency is toward a knock-
kneed appearance. This latter is intensified by the fact that
the hips of the female figure are very broad and the lines
from the hips to the knees taper very rapidly. Thus, this
knock-kneed appearance exists even where, as a matter of
fact, the limbs are perfectly straight.

26. Fig. 19 shows the comparative proportions of the
male and female thigh and leg when viewed from nearly the
same standpoint. Assuming the calves to measure practi-
cally the same in circumference, it can readily be seen that
the female thigh and knee are rounder and larger than the
male and that the lines causing this appearance are on
the outside of the leg. On the outside line of the lower leg,
however, the contours are nearly the same; but on the inside
line the most prominent point of the calf is higher and con-
siderably greater in the male figure than in the female.
This difference of appearance is due largely to fat filling
the space below the knee in the female figure, the muscular
development of the male being more defined than that of
the female.

In the comparison of these two limbs one can see the
characteristic difference between the male and the female
figure, the former being sharply contoured and muscularly
expressive, the latter being soft and undulating in its form.
Study, line for line, these two limbs; they will be found to
possess at nearly the same points exactly the same curves
and in the same directions, but the gradations from one

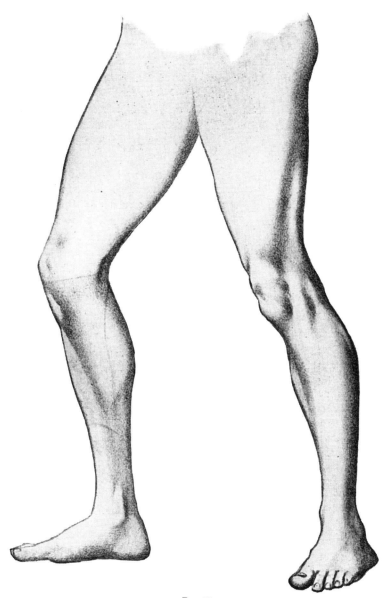

FIG. 20

curve to the other are much more delicate in the female than in the male limb. Here, too, can be observed the cause of the appearance of knock-kneedness so prevalent in the female figure, the outside line of the leg exhibiting a greater indentation at the knee in the female than in the male figure. If a straightedge, however, be laid along the inside of each of these legs from the ankle bone to the top of the thigh, it will be found, as a matter of fact, that neither is in the slightest degree knock-kneed but that the female limb is a trifle the reverse if anything.

27. Fig. 20 is a drawing of the male limbs with the weight of the body thrown forwards, thus bringing into prominence the muscle of the front of the right thigh and a fulness of the shin muscle directly below the right knee. The left leg exerts a backward pressure in this action principally on the toes and ball of the foot, and the clean definition of the thigh muscles just above the knee shows where the greatest strain comes. The muscle on the inside of the left calf also suggests pressure, and the expression of action in this figure is due entirely to the modeling about the knees and along the sides of the limbs that shows the tensity of this muscle.

In the left leg the curve of the shin bone from the knee down is strongly indicated by the shadow on the inside of the muscle. The right foot is in full profile here, while the left foot is foreshortened in front view, and forms an excellent study in the relative points of prominence in the ankle both outside and inside.

Fig. 21 is a study of modeling to indicate the muscular forms in the male limbs when viewed from the side and posed somewhat as in Fig. 20. The definition of the knee joint and kneecap is very clearly marked here and the ankle bone stands out with great prominence, showing the point of hinge or turning at this member. The depression above the kneecap in the left leg appears here, giving fulness to the muscle above it in the same manner as in Fig. 20, but the point of view being farther to the right than in Fig. 20,

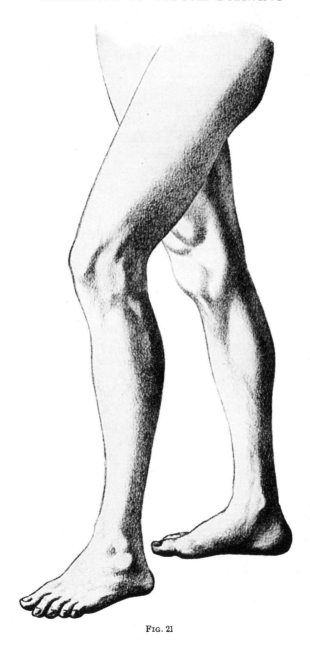

Fig. 21

we lose sight entirely of the prominence on the inside of the calf.

In studying from the model, at all times take advantage of opportunities to walk around it and notice the change of contour at each step. As one steps to the right or left of the point of view, certain muscles become foreshortened and others come into prominence, and it is only by the careful study of these that correct delineation can be given to the subtle character of the human figure. It is only by this study and the repeated drawing from the figure in these positions that the details can be impressed on the mind sufficiently to permit the correct delineation of forms in illustrative work.

Fig. 22 is a direct view of the prominent points on the inside and outside of the left leg when seen from behind. In the outside of the thigh there is very slight convexity, while in the line of the inside there is a slight concavity about midway to the knee. The point of prominence in the outside of the calf is higher than the point of prominence on the inside of the calf; the location of these points of prominence is an important detail that should be studied from the living model, as the position of the feet has a strong influence in the general contour of the leg. For instance, in Fig. 22 the foot of the left leg rests at a given angle, thus causing the contours of the leg to assume a certain definite form, but the foot of the right leg is turned outwards and the contours of this leg are considerably changed. Not only is it important to establish these contours correctly in order to satisfy the eye as to the accuracy of the drawing, but the shadows indicating the planes must be well placed, or the whole composition will be incongruous and unsatisfactory.

In Fig. 23 the smooth, unbroken quality of the outline is strongly indicative of the female figure. The flesh is laid so smoothly over the muscles that their characteristic prominences are almost entirely hidden. A comparison of the rounded, undulating forms here with the knotty, muscular development of Figs. 20 and 21 again illustrates the

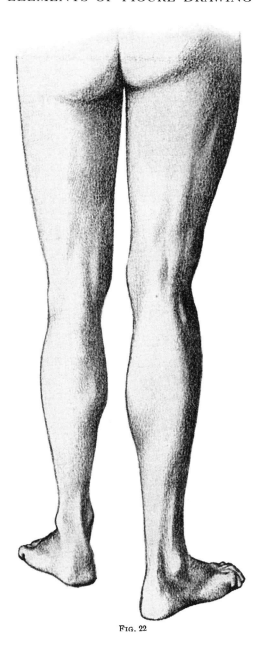

Fig. 22

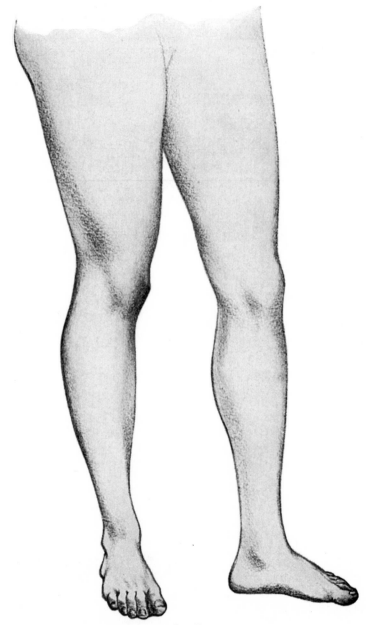

Fig. 23

distinguishing characteristics of the male and female figure. Here, as in Fig. 19, the thigh is shown round and full, and the construction here and in the knees is almost entirely obscured by the presence of fat. The width of the hips is especially noticeable, although the figure for the most part is rather slight.

Fig. 20 showed a profile of the right foot as seen from the inside; here is shown a profile of the left foot as seen from the inside. The one being male and the other female, however, there are slight differences in contour, but the rise of the ankle from the instep and heel can be profitably studied from both points of view.

28. In Fig. 23 the comparative size of the thigh and calf of the female figure are well shown. Owing to the anatomical character and great width of the female hips, a large thigh is a necessity in order to give grace to the leg; otherwise, the lines from the hips to the knees would be concave, giving an appearance of awkwardness and weakness. Here can also be observed another characteristic that offsets this tendency to weakness in appearance; that is, the fulness of the calf on the outside and the tendency of the same to a straight line on the inside. The foot here is in full front view, and the right leg is shown foreshortened, as seen from a point considerably above its level, while the foreshortened left foot in Fig. 20 was seen from a point very little above its level. In the right foot shown in Fig. 23, two prominent points of the ankle bone should be studied carefully. Whenever opportunity arises this should be studied from the living model, inasmuch as the points of prominence on the inside and outside vary constantly with changes of position.

THE FOOT

29. In drawing the foot in profile estimate its length by comparison with some fixed scale of measurement, such as the head, or by the proportion it bears to the length of the leg from the knee to the sole of the foot. The contour of the instep, the position of the ankle bone, and the shape of

FIG. 24

the heel are next in importance. In its main lines the form of the block foot, Fig. 24, will be brought to mind, although the surface is much rounder and more varied, thus making modeling much more difficult. In the direct front view the size and position of the toes and the relative position of the outside and inside prominence of the ankle bone are very important, and must be studied very closely.

There are many other smaller muscles throughout the body that are of importance in artistic anatomy, but the ones given have the most direct influence on the shapes of different parts of the body in various positions and should be studied carefully whenever opportunity affords in order that their true value may be appreciated.

THE FIGURE

30. In general, among artists and models the term **figure** is used to indicate the nude figure, male or female. Drawings or studies from draped models are usually termed *character* or *costume studies*. So, wherever the expression is hereafter used it will be understood that lines of the figure refer to lines of the nude figure. Having studied many details concerning the general proportions and characteristics of the arms and limbs, the trunk, or torso, as it is termed, and the figure as a whole will now be considered. For this purpose it is best to have a model; if one is not obtainable, the next best thing is a photograph of a nude figure showing the characteristics to be pointed out.

It should always be borne in mind when studying from photographs or living models that perfection of line and proportion does not exist in any one person, and that subjects available for models are not selected on account of the perfection of their anatomy but simply to illustrate characteristics of individual figures, which form an endless variety throughout the human race. The artist in painting a classical picture may use one model for the head and face and several others for other portions of the body. He may idealize somewhat or he may hold strictly to the characteristics of the model before him.

In the following photographic illustrations attention is called to the general characteristics of the human figure as a whole and to the particular characteristics of this individual model, in order to show details and characteristics that might be found in other models.

31. In Fig. 25 is shown a front view of the female figure divided vertically by a series of horizontal lines indicating the number of heads in height; these heads are numbered from *0* to *8*. This model is exceptionally tall for a female figure, but has been selected to illustrate the proportions on which the human figure is more generally based. Observe that the feet of the figure end midway between *7* and *8*, showing the figure to be seven and one-half heads high. The space between *0* and *1* is somewhat less than the other spaces, as the head is thrown to one side and the length indicated by the diagonal *0 1*. Observe also the breadth of the body at line *4*, which is just below the broadest part of the thighs, and the taper almost in straight lines from this point to the knees. This figure is less than two heads wide at this point, but is fully two heads wide—including both arms—at line *2*, which passes, as will be observed, through the nipples. The right nipple of this figure, it will be observed, comes above this line, as the right arm is thrown over the head, thereby raising the details of that side of the body. Three heads below the crown the line passes through the navel, and four heads below the line marks the pubes or end of the torso. The knees are located between lines *5* and *6*, and the broadest part of the calves is just below *6*, where the taper is rapid and direct to the ankles. From their point of junction with the body about line *4*, the insides of the legs are indicated by a nearly straight line to *6*, where it trends somewhat outwards, giving this characteristic knock-kneed appearance, which is intensified by the great width of the hips. The lines on the inside of the legs are very simple throughout, and the form of the

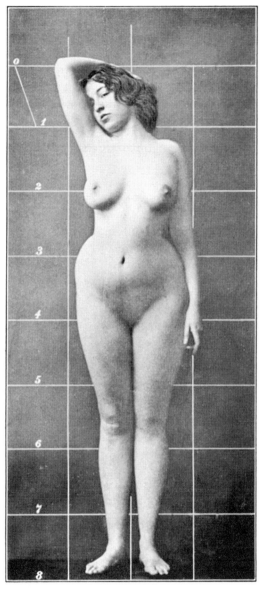

Fig. 25

mass in drawing is dependent entirely on the contour given to the lines on the outside of the legs.

These general contours should be carefully studied so as to see the main trend of lines and points of muscular prominence. In drawing from such a figure the width of the hips between lines *3* and *4*, the breadth at *4*, the contraction at the knees, etc. should be carefully noted, and the general outline swept in by broad, straight strokes that give the general proportion and contour at once in as few lines as possible. After these general lines are drawn in they can be worked to proper curvatures, planes of light and shade carefully studied, and the figure modeled into form. The modeling of the breasts is very subtle and is dependent entirely on the proper placing of the planes of shade. In this position there is no outline save where the right breast extends beyond the line of the body.

This figure is unusually narrow at the waist line, between *2* and *3* — an effect characteristic of certain types of women, owing to customs of tight lacing, etc. Oriental females do not possess this characteristic.

BACK VIEW OF THE FIGURE

32. Fig. 26 is a back view of the figure in practically the same position as that shown in Fig. 25, except that the left arm is thrown over the head in order that the general outline may be as nearly the same in the two cases as possible. The excessive narrowness at the waist line is more noticeable here than in Fig. 25, and although the upper part of the figure is sufficiently slender to show the bony construction and muscular covering thereof about the shoulders and arms, the buttocks and thighs are so loaded with fat that all suggestion of bony structure is lost as far down as the prominence on the inside of the knee. The knock-kneed appearance of the figure is still more noticeable than in the front view, as the line separating the two legs is not straight but distinctly angular at the knee.

Note here, in comparison with Fig. 25, the position of the

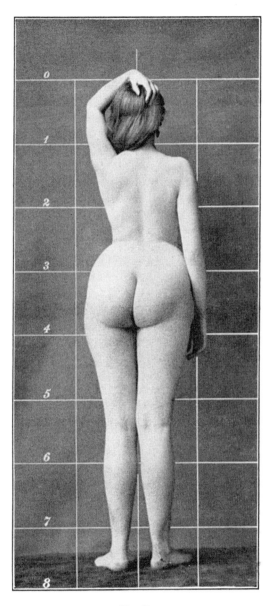

Fig. 26

lines marking the head-lengths. Line 2, which in the front view passed through the nipples, in the back is a little less than midway between the shoulder and the waist line; and line 4, which marked the termination of the torso in Fig. 25, here falls below the buttocks, showing that this portion of the figure is higher than the pubes. Note that while the line from the left elbow to the waist is nearly straight in itself, it is broken by a series of delicate undulations so subtle as to be scarcely noticeable, yet of importance in rendering graceful the outline of the figure itself.

The fat and skin spread over the muscles of the back and prevent the proper appreciation of their construction. The skin has a tendency to smoothen the entire surface into a mass of delicate undulations so that the identity of separate muscles is entirely lost. In the back view, two muscles, called trapezius muscles, cover the back and shoulders like a pointed cape, the point coming below the middle of the spine and the upper edge extending across the shoulders over the ends of the deltoid muscle. Several lateral muscles are stretched each side of the trapezius, covering the ribs at this part and giving roundness to the trunk. The hollow usually termed the small of the back is covered by a long muscle extending into the great muscles of the buttocks, which are termed the glutei muscles.

In rendering this figure, the point of the wrist above the crown of the head, the elbow, the left armpit, and the waist line will form points of prominence between which the first general outlines may be swept, the outlines of the lower portion of the body being located through points similar to those indicated in Fig. 25.

<hr/>

THREE-QUARTER VIEW OF THE FIGURE

33. In Fig. 27 the figure is posed with both arms above the head in order to more clearly show the construction of the body. Here it will be observed that line 2 passes through the nipple of the right breast, while it falls below the nipple of the left breast. Both of these breasts are

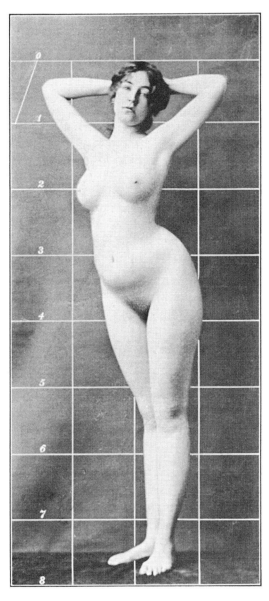

FIG. 27

raised by the action of the arms, but as the body sags slightly to the right the trend of the lines causes this contradiction to Fig. 25. Note, also, that the nipple of the left breast is exactly in the center of the breast, while the one on the right is in full profile. This is an important characteristic to be observed in the female breasts. They are practically at right angles to each other in plan, so that the axial lines through both nipples will meet each other at an angle of 90° within the body. Between lines *3* and *4* on the under part of the abdomen is a deep shadow showing the overhanging prominence of that part of the body. When seen more in profile, this overhanging prominence is still more striking and gives the appearance that a part of the waist is carried forwards from the hips. This is a characteristic of the female figure, as the knees have a tendency to be sprung well back, but this tendency is exaggerated owing to peculiarities of female dress that have, in many sections of the world, changed the form from what nature intended it to be.

In Fig. 28 the pose is changed slightly in order to show the relative positions of the legs. Here the overhanging prominence between lines *3* and *4* is still further illustrated. The broad, upward sweep of the hip line to between lines *2* and *3*, running nearly parallel with it, gives this forward trend to the figure characteristic of the female. The fact that the line of the front of the leg or shin between lines *6* and *7* has an inclination that makes a distinct angle with the line from *4* to between *5* and *6*, adds more to this appearance of forward projection of the figure.

In searching for points on which to construct this outline one will naturally discover that the under sides of the arms, where they join the body, form two points of starting. The location of the nipples, navel, and pubes at lines *2*, *3*, and *4* gives definite points about which the right side of the figure can be constructed. The line from the armpit to the curve of the thigh and thence to the broadest part of the buttocks between lines *3* and *4* is easily located, and general sweeps through indicative points will model the limbs.

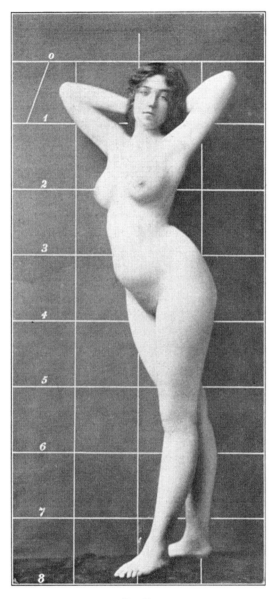

Fig. 28

This forward projection of the upper part of the body will at first appear a distortion, but a careful study of photographs and good drawings of women in the modern American and European style of dress will show why this appearance is not noticeable. The dress hangs straight from about line *3*, in front, to the floor; whereas, in the back it hangs straight from the rounded outline of the hips and buttocks. The curves, though naturally blended into one another here, are increased by the use of corsets, in order that this part of the body through its suppleness will not distort or interfere with the hanging of the garments.

SIDE VIEW OF THE FIGURE

34. In Fig. 29 is shown a side view of the figure in a rather conventional position in order to indicate the relative position of the various members, as compared with previous figures where the model was standing. Here the position of the arm hanging by the side in profile, and the curve from the under side of the chin to the breast can be studied. It will be noted that the line of the back disappears entirely behind the arm, but this illustration is of importance to show the effect of relaxation on different muscles. The breasts, relieved of the lifting tendency caused by the arms in previous cases being thrown above the head, now fall to their natural positions and the line of the abdomen flattens out, as the muscles in the upper part of it, being in repose, no longer support the under part. The contour of the calves of the legs, the instep, and the foot in profile is illustrated here.

In drawing the side view find convenient points for bounding the outlines, in the pit of the throat, nipples, juncture of the abdomen with the legs, the knees, ankles, and toes. Study carefully the planes that indicate the contours of the various parts and note how subtle are the curves that characterize the details of the figure.

In Fig. 30 we have another seated posture in which the parts are more foreshortened. Compare the proportions of

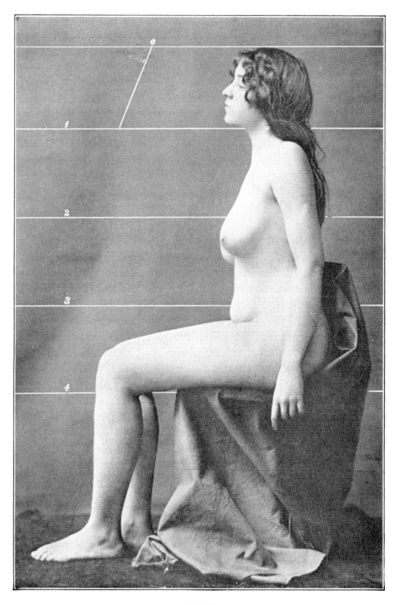

Fig. 29

the parts of the body from the top of the head to the base of the trunk, from the base of the trunk to the knee, and from the knee to the ground. The head as a scale of measurement is indicated here by lines, those on the left leg being indicated in a diagonal direction in order to be at right angles with the member.

In Fig. 29 it should have been noted that the elbow falls just above line *3*, as can be seen also in Fig. 25; while in Fig. 26 the elbow is considerably below the waist line at the back. In Fig. 29, however, the waist line does not appear distinctly, but the shadow on the inside of the arm would indicate it to be very nearly at the level of the elbow, thus showing that the waist line has been pushed up somewhat in the seated posture. In Fig. 30 the waist line is distinctly visible just above the elbow, and proves that this change of posture has produced a change of position.

In Fig. 30 considerable attention should be given to the location of the shadows. The face is divided by a distinct line through the center; beneath the chin as the shadow falls on the throat and shoulder it becomes diffused, but when viewed with partially closed eyes its margin is distinctly discernible and its characteristic shape can be studied. A triangular mass of shadow marks the turn of the breast into the side, and beneath the breast a small patch of deeper shadow shows, by contrast, the general form and contour of the breast. On the thigh and down the side of the leg the shadow is very diffused, but its margin becomes sharp near the knee and on the ankle and can be indicated if carefully studied. The right foot, as it turns under the knee of the left foot, is a difficult piece of foreshortening. The under side of the foot is partially visible here, although in deep shadow.

The high light accentuates the outline, and the planes should be carefully studied with partially closed eyes in order that proper values may be given. The right arm is entirely lost behind the front, but it throws the left breast into profile against the background and characterizes the ease of the pose.

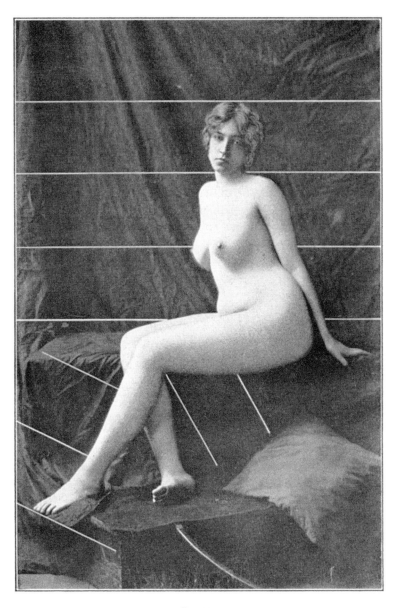

Fig. 30

THE PROSTRATE FIGURE

35. In Fig. 31 the pose ably illustrates the contour of the back of the figure. Here the long, gently but beautifully, undulating line from the heels to the shoulders is characteristic of all the other poses heretofore considered. Note a deep inward curve at the small of the back, here intensified by the position of the shoulders, which are thrown forwards as the arms are thrust upwards. The gentle fall from here to the waist and the sharp upward curve give prominence to the buttocks. From the buttocks to the back of the knee the line is nearly straight, and from the knee to the heel the compound curve characteristic of the back of the leg is very prominent.

The modeling is simple in a case of this kind, and the lines are clean cut and the margins sharp. The arms and hands stand in full relief against the background, while below the shoulder of the right arm a deep shadow marks the shape of the deltoid muscle. Beneath the hip also a dark shadow can be seen showing the contour of the muscles at this portion of the body where they merge into the back. On the foot are three distinct planes of shadow, each of which is well defined: the darkest is from the toes to the instep, the middle tone on the instep, and the lightest tone indicates the side of the foot.

In Fig. 32 the sinuous and serpentine character of the figure is well illustrated by the pose. All of the parts are much foreshortened, but the beautiful outlines are sharply profiled against the background and indicate the margins of the planes distinctly. There is scarcely an angle to be observed. From the waist to the shoulder and from the shoulder to the neck are nearly two straight lines, and a right angular mass of shoulder and back where the left shoulder is profiled against the background.

Note carefully the sagging appearance that the upper leg has where it rests against the lower one, and the droop of the left foot over the end of the sofa. The appearance of weight in different parts of the body is thus represented

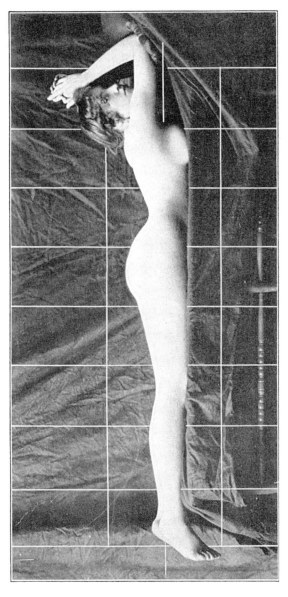

FIG. 31

clearly, as wherever the flesh is given an opportunity it sags into a natural and comfortable position. This is again indicated in the calf of the right leg, where it is flattened by the weight of the leg above it. The left hip in this pose is made more than usually prominent owing to the fact that the whole body is leveled on the lower side on account of the unyielding character of the sofa on which it is posed. In the same way in Fig. 31 the great prominence of the buttocks is decreased owing to the fact that the waist is raised slightly by the pressure of the sofa, on which the figure is posed, against the abdomen. Compare Fig. 31 with Fig. 28, and the effect of the pose in Fig. 31 can be readily seen.

These subjects should be carefully studied from all points, and in making drawings of the full figure the details and characteristics observable in these photographic representations should be borne constantly in mind. The student should avail himself of every opportunity to study from the figure in whole or in part, and in making drawings and studies from the draped or costumed figure, should always endeavor to picture before his mind the general contour of the lines of the figure beneath the draperies in order that he may properly understand the causes that contribute to the various forms.

EFFECT OF THE POSE

36. Before leaving these illustrations compare them as to artistic merit due entirely to the effect of the pose or position. They are all made from the same model, and, as stated before, no model is physically perfect. In Figs. 26, 27, and 28 the defects of this form, due to fashions in dress, have already been pointed out. Tight lacing has reduced the waist below what should have been a proper proportion for a woman of this height and breadth of hips. Similar causes have thrown the upper portion of the body so far forwards that apparently the figure has lost most of the graceful delicacy of line and mass that one is accustomed to associate with the feminine form. It is evident, therefore, that attractive as this figure may be as a costume model,

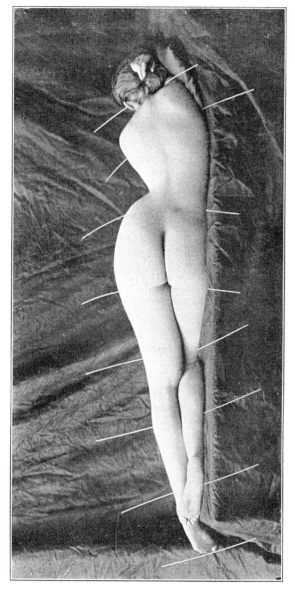

FIG. 32

serious defects present themselves in using it as an undraped classic subject.

All models except those in oriental countries possess these defects in some degree, and the artist must exercise his skill in posing his model so as to bring into prominence the beauties of her figure and at the same time hide the defects.

In Fig. 30 the model is posed so that the upper portion of the body is in nearly the same position as in Fig. 28, but the left arm is placed so as to hide the exaggerated hollow of the back. The weight being thrown on the right buttock permits the left side to sag somewhat and thus preserve the subtle curves of the hips.

In Fig. 31 the hollow back is very prominent but the pose of the figure accounts for it. The body is apparently supported at the knees and chest, and a sag in the hollow of the back appears natural. Thus, a pose has been arranged so that what in truth is a physical defect appears to be the result of natural conditions.

The same treatment may be observed in Fig. 32, where the broad hips and narrow waist are made to appear natural owing to the fact that the figure is lying upon a flat surface and the shoulders and hips seem pushed above the horizontal line.

THE FEATURES OF THE FACE

37. The expression of the eye is almost entirely dependent on the shape of the eyebrow, the lids, and the bone structure in which it is set. All the varied expressions of love, pity, fear and grief, indignation and joy are due to the muscles around the eye and not to any expression of the eyeball itself. The words of a well-known artist and teacher, "The eye has no more expression than an oyster," are true when we consider the eyeball itself without any accompaniments.

The nose shows considerable character in its formation, but is only slightly mobile or changeable, being restricted to the variation in the dilation or size of the nostrils and a few other trifling muscular movements, such as the raising of the end in an expression of deep appreciation or disgust.

The mouth, with the eye, possesses the greatest range of mobility and contributes most to the variation of expression in the face.

The ear and chin are the least mobile of all the features and depend for their character entirely on their general formation. In constructing the head, the ears are a great help, as they form a sort of axis on which the head may be said to turn; their position on each end of this axis establishes the angle at which the head is seen.

THE EYE

38. The correct drawing of the human eye is one of the most difficult problems in figure drawing. The convex shape of the eyeball enveloped by the lids is full of subtle variety in perspective, while the spherical shape of the eyeball proper causes the lids and other details to be somewhat in perspective at all times, no matter in what position the eye may be seen.

In general structure the eyeball protrudes from a socket, or orbit, as it is called, and is enveloped above and below by the eyelids, as shown in Fig. 33. The plane of this orbit slopes inwards as it descends to the cheek bone, as shown at *a b*, Fig. 34, and makes an angle with the plane of the forehead as the latter recedes from *a* to *d* and also with the plane in

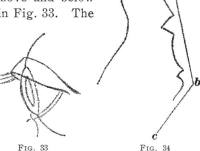

FIG. 33 FIG. 34

the cheek as that passes forwards, as shown at *b c*. Each detail of the eye, whether it be opened or closed, tends to preserve the direction of the plane *a b*, and the eyeball never protrudes sufficiently from its socket to disturb the slope. The upper lid extends beyond and partially covers the upper portion of the iris, while the iris slopes backwards with the

plane of the orbit. The under lid is thinner than the upper and forms the base of the plane $a\,b$, where it intersects with the cheek plane.

The eyebrows start either side of the nose just under the frontal bone and extend outwards and slightly upwards,

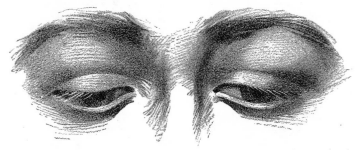

FIG. 35

tapering gradually toward the temple, where the growth ceases on the outside of the orbit, as shown in Fig. 35.

The convexity of the eyeball determines the curvature of the eyelids, but this curvature changes with every position of the head, owing to the foreshortening. In three-quarter view the upper lid makes a spiral turn that hides its thickness at the outside, as shown at a, Fig. 36, while in looking

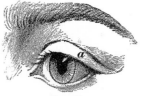
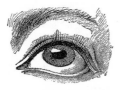

FIG. 36 FIG. 37

downwards the upper lid straightens out and the lower lid becomes more convex, owing to the fact that the eyeball is rolled into the lower lid. As the eye is turned downwards the outer corner descends slightly also, tending to straighten out the lower lid. When the eye is rolled upwards the convexity of the eyeball is emphatically marked by the upper lid, as shown in Fig. 37; its breadth is diminished, but its

thickness is visible all the way across, while the lower lid flattens out and forms a compound curve rising from the inner corner and descending until past the pupil, when it rises abruptly to the outer corner. With most persons the upper lid is more convex on the inside than on the outside, while the lower lid is more convex on the outside. From the outside of the corner of the eye the upper lid curves slightly toward the top of the iris, and then descends in a more or less abrupt curve to the tear gland by the nose; while the lower curve starts straight from the tear gland,

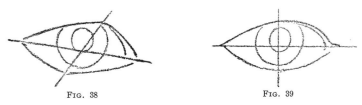

FIG. 38 FIG. 39

descends slowly, and returns in a rather more abrupt curve against the outer corner of the upper lid, so that lines drawn through the points of start and finish in the eye will intersect about as shown in Fig. 38. The eye very rarely composes itself into two even arcs from corner to corner, as shown in Fig. 39.

THE NOSE

39. Viewed directly in profile the nose starts beneath the eyebrows and proceeds at an angle until the tip is reached. The character expressed by it is mainly influenced by the bridge, while the terms Roman, straight, aquiline, and retroussé (turned up) are based on the degrees of convexity or concavity of the line from the brows to the tip. The upper lip joins the cartilaginous septum, or partition, between the nostrils at a point about midway between the extreme tip of the nose and the crease where the wing of the nostril joins the cheek, Fig. 40. When illuminated by a strong light, the margins of the shadows definitely describe and locate the planes that make up the construction of this feature.

In a full-face view, Fig. 41, the nose has its origin between and somewhat beneath the brows. At its beginning it is narrow and increases in width at the bridge; it decreases where the cartilage is reached at the end of the nasal bone,

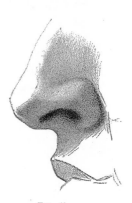

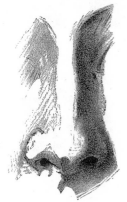

<div style="text-align:center">Fig. 40 Fig. 41</div>

but again increases, attaining its greatest width at the tip. The nose is wedge-shaped from this view, with the edge of the wedge to the front; the sides slope gradually from the bridge to the cheeks until the nostrils are reached. The base of this wedge extends outwards from the general plane of the face, as the nose is much broader at the base than at its origin between the brows. If this point is not well understood, drawings of the nose are likely to look as if the nose were pressed into the face between the cheeks. A block form of the nose is shown in Fig. 42. A sharp crease marks the formation of the wing of the nostril at the base

<div style="text-align:center">Fig. 42</div>

and lessens in prominence as it extends into the cheek. The greatest width of the nose is at the base across the nostrils.

When the nose is seen on a level with the eye the cartilaginous septum between the nostrils extends slightly lower than any other part, Figs. 40 and 41. When viewed from below, however, the wings appear to be the lowest part, as in Fig. 43 (*b*); but viewed from above, the nostrils are

completely screened, and the lower part of the tip overhangs
the upper lip, Fig. 44. When the head is thrown well back,

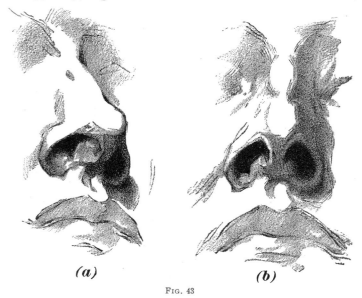

(a) *(b)*

Fig. 43

as in Fig. 43, the formation of the nostrils and the inter-
vening cartilaginous septum can be easily studied. The
unconventionality of these forms
makes definition difficult, and much
practice in drawing them is therefore
very necessary. The convex surface
of the wings and the end of the nose
should be studied in profile, full-front,
and foreshortened views. The shad-
ows on these forms better illustrate
their character than any verbal de-
scription can possibly do.

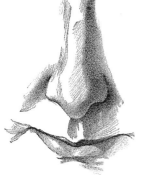

When seen from below, the bridge
from the brows to the end will lose
greatly in length by foreshortening, Fig. 44
and must therefore be carefully studied in order to avoid
an exaggerated appearance.

THE MOUTH

40. The mouth, like the eye, is one of the most difficult parts of the face to properly render, inasmuch as its form is so subtle and so greatly influenced by perspective that constant practice is the only means by which one can successfully master its subtle curves. Viewed in profile, Fig. 45, one can study the general formation of the lips. Note the steps formed by the intersections of the nose, lips, and chin

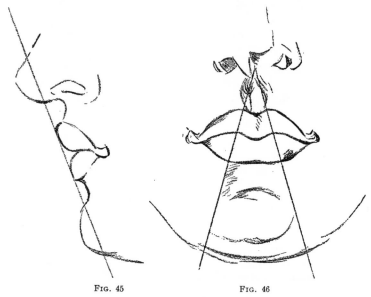

FIG. 45 FIG. 46

with the plane of the lips. In the full-front view, Fig. 46, the upper and lower lips are seen to be concave in their outlines from the middle to the corner. In thickness the upper lip is much more convex than the lower one, Fig. 45, and the curves unite in a very subtle manner with adjacent curves. In the full-face view, Fig. 47, the mass about the mouth is very convex owing to the influence of the teeth. The corners, therefore, are farther back than the middle and the concave sides become foreshortened. In the average mouth the upper lip overhangs the lower lip slightly, and in a direct

profile view, Fig. 48, the corners will be found somewhat lower than the drooping middle portion of the upper lip. The mucus, or red, portion of the upper lip may be divided into two planes, *a* and *b*, Fig. 49, while the lower lip possesses three planes, the middle one *c* extending each side

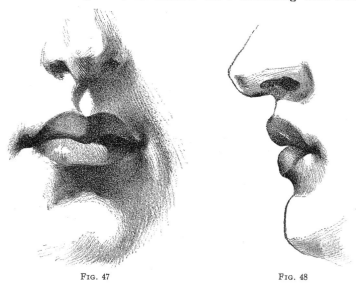

<div align="center">

Fig. 47 Fig. 48

</div>

of the center of the upper lip and the two side ones *d* extending into the corners of the mouth. The degree of curve and fulness in the lips is a matter of individual character, varying from a distinct bow shape to lips that are so thin and straight as to be scarcely more than a straight line across the face.

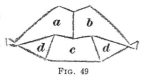

Fig. 49

The concavity beneath the lower lip is largely influenced by the fulness of the lip itself and the pressure brought to bear on it by the upper lip. Viewed from the front, Fig. 47, the depression that divides the upper lip beneath the nose widens as it descends toward the mouth and marks the middle of the upper lip. The little concave depression in the middle of the curve of the upper line of the upper lip

seems to be duplicated in the curve of the lower line of the upper lip, both curves forming the boundary to the thickness of the lip at this point. From the middle, the upper lines of the upper lip curve downwards toward the corners, while the

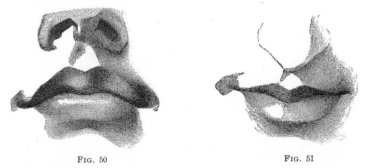

FIG. 50 FIG. 51

lower lines of the upper lip follow approximately the same direction and the two meet in the depression at the corner. In direct front view the degrees of convexity and concavity in the form of the lips are expressed by the intensity and shape of the shadow.

In various foreshortened positions in which the mouth is frequently seen, the lips assume many changes in appear-

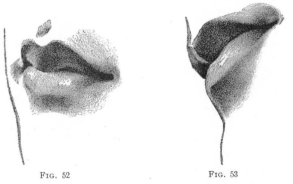

FIG. 52 FIG. 53

ance. It is plain that when observed from a low point of view, the upper lip will appear at its full thickness, Fig. 50, and the lower lip will appear thinner than when seen level with the eye of the observer. When seen from above, Fig. 51,

the lower lip will exhibit its full thickness and the upper lip will appear thinner than when seen on a level with the eye.

In the three-quarter view, Fig. 52, the nearer side of the

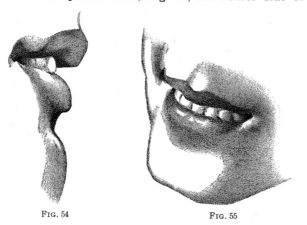

<div style="text-align:center">F<small>IG.</small> 54 F<small>IG.</small> 55</div>

mouth from the middle to the corner is seen in its full dimension, losing nothing by foreshortening; the other side, however, appears much shorter, and in some cases the space between the middle and the farther corner will be lost entirely. A three-quarter view of the mouth from below, Fig. 53, is influenced by perspective from two quarters, the point being to the side as well as below. The curves from this position, as well as a three-quarter view from above, should be carefully studied.

The mouth and eyes combine to give various expressions to the face. When the lips are parted slightly, as in

<div style="text-align:center">F<small>IG.</small> 56</div>

Fig. 54, the teeth show within and a half-smiling expression is given this feature by slightly raising the corner. In front and three-quarter views the lips lengthen and flatten out

in the act of smiling, as shown in Fig. 55. In Fig. 56 is shown the outline construction of the mouth illustrated in the previous figure. Note the foreshortened profile line through the center of the lips and chin. This line is identical with the profile shown in Fig. 45 except that the lips are parted.

THE EAR

41. Viewed in profile, with the eye of the beholder on a level with the ear of the model, the top of the ear will be about on a level with the eyebrow and the bottom of the ear will be nearly on the same line as the base of the

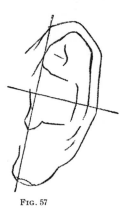 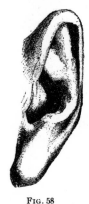

FIG. 57 FIG. 58

nose, although this detail varies in individuals. The ear occupies a position somewhat back of the center of the head, and in the classic figure the top of the ear rests on a line midway between the top of the head and the bottom of the jaw. The general direction of the ear is slightly at an angle, the line from its center pointing slightly toward the chin, as shown in Fig. 57. The form of the ear is decidedly unconventional, and must be studied carefully to be well understood. In its numerous concavities and convexities various shadows are cast, in the location of which lies the secret of rendering it properly. These shadows indicate every winding recess of the bowl and every prominence

and hollow in the brim. In the front, or three-quarter view,
Fig. 58, the lobe of the ear is closely attached to the head,
but the upper part is much less so, as is readily seen when
the ear is viewed from behind, as in Fig. 59. In Fig. 60, the
ear is shown in full elevation or as it appears when the head
is in profile. The student should locate certain distinguish-

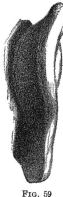
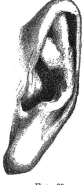

FIG. 59 FIG. 60

ing characteristics of this feature and note their differences
in the different persons that he meets in every-day life.

The ear is very intricate in its formation, and in fore-
shortening of the head, the proper placing of this feature
is of the utmost importance. As said before, a line through
the head from one ear to the other forms an axis, so that the
placing of the ear is a sort of key to the action of the head.

THE CHIN

42. The bottom of the chin is about one-third the length
of the face below the nose when in profile. The back
part of the head at its lowest extremity is about on a level
with a horizontal line drawn across the head at the base
of the nose. Thus, it will be seen that the front of the head
bears a proportion of three parts to two when compared with
the length of the back of the head, and that this extra third
portion includes the mouth and chin.

Where the head is thrown well back, the back portion of

the head is lowered and the chin raised, and great care must be exercised in order that their proper relative positions are preserved. When observed from below, the chin is more in the foreground than any other part of the face; but when observed from above, the chin is more in the background than any other portion of the face. Observance of these effects is of the utmost importance in rendering these details.

LIMITATIONS TO MOVEMENT

43. In drawing the full-length figure it is of the utmost importance that every structure should come within the bounds of possibility. For instance, when viewed from the back the neck has a limited range of movement beyond which it cannot turn, and if a drawing represents a head in one position and the back and shoulders in such relation to it that it is unnatural, the whole drawing is bound to appear out of construction. Also, in a drawing of a leg where a view of the knee, the foot, and the ankle is given, it must be borne in mind that with various positions of the foot and ankle, certain corresponding positions of the knee must be represented, and anything beyond these throws the body out of construction. When the hand is in pronation, the muscles of the forearm assume certain prominences, and care must be taken that these prominences are not shown when the hand is in supination or in any intermediate position.

Whatever portions of the body are turned by strong action, they all have a limit to their power of turning, and all the prominences of the muscles are characteristic of certain positions. When one draws these details beyond such limitations of possibility, he not only throws his drawing out of construction but tends toward a line of work known as caricaturing, where grotesque forms are produced by the introduction of these excesses. Probably the most prominent defect of this character is seen in some cheap lines of illustration where the neck is turned outside of its limit of movement, and possesses a stiff, unnatural appearance characteristic of the work of the untrained artist.

It is a common error of beginners to endeavor to draw everything in outline before any attempt is made at construction or building up. One should take in the whole model as a large, simple mass and postpone all the details until the general plan is completed. Erasure should be avoided as much as possible, and until the general construction lines are correctly located and drawn, no modeling should be attempted. The work in cast drawing of block forms of the hand and head should be borne in mind, as the simplicity of mass in these details should be fully applied to drawing from the figure. After the main directions and proportions are rendered, a careful study of the outlines can be made, substituting accurate lines of contour for the simple lines of construction. But, it should be borne in mind that good work in modeling can never be accomplished unless the structural form is correct to start with.

While it is bad practice to endeavor to draw figures out of the mind, it is good practice to draw carefully from life and then without the aid of either the model or the original drawing to redraw the figure from memory. This second drawing can be compared with the life drawing to see where the memory has failed, thus impressing on the mind certain details that one is not likely to overlook again.

One should walk slowly around the model and observe the difference in appearance that the various parts assume with his change of position. The eye will thus become accustomed to the appearance of the figure in its common attitudes and the relation that various forms bear to one another. When parts of the body are known to be correctly placed and to occupy the proper amount of space, they should be drawn carefully in detail, as, for instance, the ankle and foot or the wrist and hand, and the memory test should then be applied to these details also. While the position and proportion of the torso, or trunk of the body, is of vast importance, the greatest majority of practical work in figure drawing requires more minute familiarity with the details of the head, hands, and feet. The rest of the body is usually covered with clothing, which adheres

more or less closely to the form but is not directly influenced by muscular prominences and developments. The position of the arm, however, the folds of the draperies, etc. should always be closely studied, as in the draped figure these details take the place of the change of muscular forms that are found on the nude figure with differences of position.

In most drawings the foot is clothed with a shoe or slipper that makes modeling of the individual toes unnecessary, but the position of the ankle and trend of line from the lower leg to the foot are all matters of greatest importance, greater even than the actual modeling of the foot itself.

DRAPERY

44. In the study of drapery the appearance of the folds and creases is dependent largely on the weight, thickness, and general texture of the fabric as well as on its age and the uses to which it has been put. In an old coat sleeve, for instance, the folds or creases about the elbow will produce, as a rule, a repetition of themselves when the arm is in the same position even after it has been changed. This, as can readily be seen, is due to the repeated foldings in the same place. But, in fresh cloths the folds will arrange themselves differently even though the cloth is placed approximately in the same position that it was in before. The study of drapery is therefore important in order to observe the general directions of the folds under certain conditions and the representation of the texture of the material by the characteristics of the folds as well as by its light and shade. Heavy fabrics will hang in larger folds than lighter ones and these will be blunter at the angles. Generally, however, there is a sort of anatomy to the fold that gives it a definite structure common to all fabrics under similar conditions.

In the case of an ordinary coat sleeve, which is practically a cylinder of cloth with an arm inside, the general trend and direction of the folds at the elbow will be practically the same in most cases even though the fabric be new, whereas

in a broad and loose sleeve, usually termed the Bishop sleeve, a more extensive range is likely to be observed and no set characteristics can be determined. In the same way, any tight-fitting garment will fall naturally into repetition of old creases. A tight-fitting pair of trousers will crease in much the same way each time the knee is bent, whereas Zouave or bloomer trousers will display a great variety in the folds. It is a study of this variety of creases that gives character to the goods and the garment. Old clothes will naturally possess numerous creases; new clothes but few.

In the cases of silk and satin the gloss and smoothness of the material causes it to catch the light and add another complication to the appearance of these folds. The reflection of light from one brilliant surface to one that is practically in shadow renders the shadow more transparent, and detail in the shadows much more clearly defined than with goods that do not reflect the light. Again, in semitransparent fabrics, such as cheese cloth and veilings, the effect of drapery is very complex as the light is seen shining through one thickness, giving it a transparent effect, but beyond this it appears opaque owing to the fact that one or two thicknesses lie so close to some solid material that the light passes no farther.

After practice, one will find it much more simple to remember the form, characteristics, and construction of the face and figure, than of the folds and creases of various drapery.

In opaque fabrics, such as woolens, the laws of light and shade are not influenced by the gloss or reflections from shiny surfaces, and the appearance of these goods is brought out by the modeling, in the same manner that one models the shadows on the human figure. All the convex portions of the folds receive high light, and the shadows cast from them on the concave portions are very dark. These numerous complications make it necessary to work always from the draped figure or model when rendering draperies, as the true characteristics cannot be expressed from mental conceptions until one has had great experience in this direction.

In Figs. 61, 62, and 63 are shown reproductions of Mr. Sargent's mural painting in the Boston Public Library, which is well worth attention as a study of drapery.

In the arrangement of this on the walls the section reproduced in Fig. 61 extends across the end of a corridor, with Fig. 62 on the left and Fig. 63 on the right side wall. Taken as a whole, the decoration is of importance to the student not only on account of its presentation of drapery suggestions but for the composition, from an art standpoint, illustrating the use of light and dark masses in order to properly balance the several sections. Each of the figures in this frieze presents a study of the characteristics of drapery. These draperies may be divided into three general classes: first, where the entire subject is light in color; second, where it is dark in color; and third, where the drapery consists of a combination of light and dark colored goods.

In rendering drapery, the same rules may be applied that have been used in drawing various parts of the figure. The main lines that establish the large masses are studied and expressed on paper with no attempt at accurate drawing. Over this the details are carefully worked up to such a degree of finish as may be required without attempt to destroy the large masses that have been originally blocked. Simplicity of rendering is evident in all of these figures. Special note should be taken of the long, sweeping lines that make up the figure of Hosea. The folds of the drapery are expressed by simple planes of shade, while the lines of the figure, both on the outside and within the mass, are handled with the utmost freedom. The crumpled folds around the bent arm are carefully contrasted with the simple, broad masses of the mantle as it falls from the clenched hand. The planes of shadow are well defined without being harsh. The margins of the shadows here have been closely searched and the relative values of the different masses of shade carefully estimated. Unless this be true and each had its proper value, extremes of light and dark would be likely to exist that would give a crudeness and stiffness to the garment that is not here apparent.

F<small>IG</small>. 61

FIG. 61 (cont.)

FIG. 62

FIG. 63

This drapery has been modeled practically in three tones—light, half tone, and shadow. The half tone is not very deep, and small accents of a dark tone have been occasionally introduced to give emphasis to the deeper folds. Note that all these shadows have a defined form and that when that defined form is properly drawn it is comparatively easy to determine the depth of tone that each separate shadow plane should present.

In the figure of Ezekiel, we have a similar rendering. The half tones here have a more defined form than in the drapery of Hosea. The little triangle of shadow toward the bottom of the garment, and the sharp, arrow-pointed shadow on the right arm are well defined in outline and give character and expression to the folds of the cloth about them. The deeper shadows are even more sharply defined, and if one looks at the figure with partially closed eyes these forms may clearly be observed, and the deepest shadows studied with great ease. Although it is true that shadows possess a definite outline, there are many places throughout the figures where this definition is almost entirely lost. The shadows blend so completely with the light that it is almost impossible to determine where one ends and the other commences. This is necessary to depict the softness of the garments, for if the shadows were all well-defined forms, a stiff, metalliclike appearance would be given to the texture, and if the shadows were all soft the garment would appear characterless and vaporlike. It is the due appreciation of these definite and indefinite shadow forms which gives a drapery those appearances that characterize it as a particular fabric.

In the figure of Jeremiah, the interest is centered more in its association with the accompanying figures than in the individual character of its drapery. The modeling of the mantle is exceedingly simple—confined almost entirely to a main tone of pure white with suggestions of shadows where the folds and creases are formed. A mass of shadows at the base of the garment explains rather indefinitely the arrangement and fall of the main folds. Here the head has

been rendered in a darker tone, and the figure of Jonah behind it throws into prominence the light tones of Jeremiah's garments and gives a brilliancy to them that is still further emphasized by the neighboring figure of Isaiah.

The figure of Isaiah is typical of the rendering of dark drapery as expressed in this group. The interest of the figure itself is centered more in the general mass than in any details of drapery. It would naturally appear that light-and-shade values cannot be made as striking in black drapery as in white drapery. In the latter, expression is given to the texture by the rendering of the half tones and shadows, while with dark drapery the whole mass is expressed in the deepest tone and the high lights emphasized to give depth to the folds. In this example the light plays upon the mantle in four places—just below the throat, on the hanging folds from the left arm, thence upon the folds across the breast, and in a thin streak down the folds from the right arm. In studying light drapery we look for the plane of shadow; in studying dark drapery we look for the planes of light. The weight and texture of the garment is expressed by the character of the folds and the lines of its general mass. The outline at the left is almost perpendicular from the elbow to the ankle, and on the right the line is slightly oblique, falling from the right elbow to the floor just inside of the foot. The feet are expressed in a dark half tone to prevent their forming white spots that would detract the eye from the general mass. Had it been desired to express this fabric as being lighter and more flimsy in weight, the folds would have been smaller and more numerous and the general outline more broken.

In the figures of Zephaniah and Joel we have two other renderings of dark drapery, although this drapery is not as dark as that of Isaiah. The lights and shades here are far less brilliant than those on the figures draped in pure white or deep black. Only the deepest shadows are expressed in black, while the general half tone of the garment is expressive of the tone value of the goods. The shadows are well defined, but lack crispness in quality, as

FIG. 64

there is less difference in tone between the lights and shades than in the previous examples. In the pose of Joel the head is almost entirely obscured in the heavy mantle, thus giving to it a mysterious interest. One wonders what would be the appearance of the prophet's face were the mantle raised, while the wedge-shaped opening of the breast and the high light falling on the neck makes a white spot that groups well with the head of Zephaniah, arms and shoulders of Obadiah, and the solemn white figure of Hosea.

In the figure of Daniel we have a combination of both light and dark draperies. The white mantle is apparently of more flimsy material than that upon the neighboring figure of Ezekiel, which hangs in straight folds from the chest to the feet, minor draperies and folds being expressed where it hangs over the wrist. The head-piece, of similar texture but darker, contrasts well with it and expresses its texture by a few sharp accentuations of shadow expressing its careless arrangement about the shoulders. Each of these figures is worthy of study in the modeling of details required to express difference in garment, in weight, color, and tone.

Note how the black-and-white garments of Micah are vigorously rendered, the lower garment being in mass with few folds expressed, while the upper portion in white lies in heavy folds about the shoulders expressed by means of a few masses of shade placed on the under side of the creases. Although the garment and the flesh as exposed on the left breast are practically equal in tone, the difference in color and texture is readily appreciated by the skilful handling of the shadows and bold delineation of the extreme high lights.

45. The greatest example of moving drapery in all art is found in the Greek statue called "The Victory of Samothrace," shown in Fig. 64. The artist or sculptor has shown beneath the falling draperies the vigorous contours of superb womanhood. There can be no doubt that he had a model for the figure itself, but the clinging, whirling draperies characteristic of action could be the result of nothing short of patient study and keen appreciation of the appearance of

light fabrics on a rapidly moving figure or one affected by high wind. This requires an appreciation extremely keen and a memory that can produce an effect in folds that the eye is not quick enough to see. One can readily understand that it would be impossible to work from moving drapery, as the multitude of changes would render it impossible to record any one condition, but in painting, drawing, and sculpture the appearance of moving drapery can be effected by recalling to the mind the impression of this multitude of flitting shadows that one sees when drapery is in motion.

In Fig. 65 is a reproduction of a well-known painting by the artist Asti, and should be studied with relation both to its composition and the rendering of its drapery. The delicate outline of the features is clearly profiled against the dark mass of hair falling about the shoulders. The play of light and shade upon the hair gives it a loose, free appearance, characteristic of its soft, crinkly nature. The pose is dignified and well balanced, the head in full profile, and the body in three-quarter view. The positions of the nipples illustrate clearly the angles at which the breasts are placed, the right being in full profile and the left in full front view. The angle at the waist line above the left wrist indicates that the figure rests firmly upon the left leg, and the beautiful modeling of the left arm is clearly profiled against the hair as it falls over this side. Throughout this entire figure the modeling is light and delicate, the arrangement of the hair being particularly noticeable in order to give luminosity and realness to the body. The drapery sagging from the waist in heavy folds shows that it is of heavy goods, and apparently has slid from the figure from its own weight. The surface of this drapery is mottled in appearance, indicating that it is a figured goods, but no definition is given to the figure itself, as this is a matter of no importance.

FIG. 65

COMPOSITION

46. In drawing the human figure for an illustration or design, the composition is the first detail that should be considered. The first requisite of composition is the mental conception of the scene that is to be depicted; a rough expression of this subject can then be rapidly sketched without a model, giving approximately the position and action of the figures and a definite idea of what are to be the main details of the background. When this rough sketch or working scheme is about satisfactory, the making of the illustration itself can be proceeded with by posing the models as nearly as possible in the attitude of the first sketch and then working directly from the live subjects. The mental idea of the character of the figures that were intended in the original sketch should be preserved, notwithstanding the differences there may be between them and the models.

The model is simply a link between the real and the ideal. We work from the model in order that the drawing may be correct and that the construction may be good, but there is no law of art that hinders one from improving on the model so as to bring the finished drawing up to his ideal. The use of a model for illustration does not necessitate the making of a portrait, and in some cases it may be advisable to have several models from which to work out parts of the same figure, while in other cases one model can pose for several figures depending, of course, on the importance of the conditions.

When the figures have all been drawn in, the background and accessories should be carefully worked up, but care should be taken that the background is worked sharply to the outlines of the figures but never encroaching on them. Close attention to the consideration of perspective is imperative, as there is always a general tendency to make the foreground detail too small, thereby destroying all effects of depth.

47. In illustration work it is always best to bring the drawing out to a definite outline and include it within a

rectangle or other geometrical form, rather than to vignette it or cause it to fade into the color of the paper toward the edges. There are cases where an individual figure, somewhat of a portrait so to speak, may be treated in the latter way, but accessories and details should be omitted in such a case.

48. Never feel the slightest hesitation in drawing figures back of figures or details back of other details. Timidity often arises from those working with the fear that the effect will be to merge the background into the foreground or vice versa, but there is no occasion to worry over this, as it is the mind and not the eye that takes in the composition and separates the background from the foreground and the middle distance from the distance. The artist confines himself to representing the various parts as they would appear in their various positions, and the eye accepts this representation while the mind interprets it as the artist intended it should be. The artist never attempts to tell the whole story in detail in an illustration. Something must be left to the imagination, and for that reason distant objects are but hazily represented, and the attention is concentrated on the principal figure in the picture without anything to detract from it. It is not necessary always that the entire figure should be shown, as the portion of a figure appearing from behind another figure or some other detail excites the curiosity and produces a reality and an interest that the presentation of the entire figure would not possess.

49. Care should be taken in illustration not to use extremes of color, as if in finishing up necessity is found for the introduction of strong lights and shadows in a few places, the whole composition is rendered in such extremes that higher lights or deeper shadows cannot be rendered. The center of interest in a picture should catch the eye at once, but it need not necessarily be in the foreground. It may be centered in some details in the middle distance or the background, and the whole foreground, elaborate though it may be, can be treated as an accessory. In such a case

the foreground, although receiving its full value as to size, modeling, and color, is made secondary by the action being placed in the middle distance or background.

The action in the middle distance or background is fre‧ quently intensified by the foreground figures being introduced as witnesses of it. By this device the observer is directed to the center of interest by the attitude of the foreground figures in the picture.

50. In depicting some action that is practically impossible for the model to assume, such as running, jumping, wrestling¡ etc., it will be necessary to depend entirely on one's knowledge of construction. A running figure is much easier to depict when draped than when undraped, as the drapery assumes planes and folds that are characteristic of the action and which change their position so rapidly under the influences of the action that the eye is not accustomed to seeing them with any degree of exactness. In the undraped figure, however, it is necessary that the muscles, which through their action change all curves and contours of the body, should be properly expressed, and that fulness of the members should not be misplaced.

For composition work one must have a strong mental vision of just exactly what he wishes to express, and the ability to properly express such parts of it as cannot be taken from a model, as well as those parts that can be posed.

DRAWING FROM THE FIGURE

INTRODUCTION

1. The student having studied the details and character-
istics of each feature of the human figure, will now put to
practical use the information thus acquired by rendering a
series of drawing plates for criticism, in order to acquire a
working knowledge of figure drawing. It must be borne in
mind, however, that the mere copying of drawings is a poor
method of learning the characteristics of the figure. The
student should therefore work as much as possible from
the actual model, sketching from the human figure, either
draped or undraped, every time an opportunity arises.

The following thirteen drawing plates are reproduced
from the work of students in the Art Students' League, at
New York, and, as they are prize drawings, may be con-
sidered as standard examples, having been selected as the
most representative work of the class. Thus, the student has
before him the best material from which to work and at the
same time material that is not beyond his abilities, as the
originals were the work of students who had to struggle with
the same problems as the student pursuing this work.

As the female figure is used more in decorative work than
the male, it is given rather more prominence in this series
of plates, although in practical work a model should be
selected to suit the individual requirements.

Although the student is herein directed to draw from these
plates as though he had the living model before him, he
should embrace every opportunity to make sketches from life
and put into practice the instruction given.

DRAWING PLATES

PLATE I

2. To draw Plate I, pin the paper to the drawing board and mark off, approximately, the length the figure is to be, between the border lines, or about 17 inches. The figure must fill exactly this space, for reasons explained in *Elements of Figure Drawing*.

For first laying in, approximately divide this height into eight parts in order to locate the different members of the body. General, rough lines should then be drawn in similar to Plate I, without any attempt to finish any part, but merely to secure the general sketching of the figure. Rough and careless as this may appear, each line can be placed only after careful study as to its direction and purpose.

Owing to the figure having been placed above the eye, the first one-eighth division below the top of the panel will fall considerably below the chin, and as the head is thrown well backwards and the chin is much above the normal line of the first head-length, the shoulders appear high and the first head-line falls very little above the shoulders. The second, third, and fourth lines, however, fall approximately correct, as will those below, the eighth one passing approximately through the toes of the right foot. In this plate the general action and swing of the body is expressed and no attempt has been made to give any definite character to the form or the line. The weight is expressed as being strongly thrown on the right leg and foot, thus giving the right hip considerable prominence, while the lines of the left side are comparatively straight from the armpit to the inside of the knee. The median line down the front of the body is barely discernible, and about it are built the masses that constitute the two sides.

Drawn by MELVIN NICHOLS

These structural lines are very faint and difficult to trace, yet are sufficiently characteristic to express the action and are considered an excellent start toward a complete drawing. The faint suggestions of lines indicate the width of the shoulders and the length of the arms. The relative position of the hands and hips, and all the main dimensions, are thus indicated without carrying the work forwards to defined contours. The only portion of this figure that is at all carried toward completion is the head, and this is modeled in the most simple manner.

Having divided the head so as to place the features in their proper situations, carefully outline the forms of the brows and eyes and sketch in the foreshortened nose and mouth, paying particular attention to the instructions that have been given as to the appearance of these features in foreshortening. The lines of the shadows should then be carefully rendered, and an even, flat tone laid over the shadows and hair in order to better express these portions. No attempt should be made here for variety of light and shade. The shadows on the upper lip and over the eyes can probably best be expressed by applying a little powdered crayon with the point of the small paper stomp; the margin of the shadow as it blends off to the cheek may be evened off by light touches of the stomp. The hair is best left as a mass of shadow, without any attempt at detail.

This is, in general, a broad drawing, and no attempt at completed detail should be made, as the drawing will thereby fail to fulfil its purpose. In using the stomp do not rub it on the paper, but blend the shadows by light, gentle touches at the point, each touch taking from or applying to the paper a small amount of crayon. Rubbing will produce muddy and unsatisfactory shadows, and the endeavor should ever be to keep the shadows transparent and of a soft and interesting character. The whole secret of the solidity of the modeling in this head lies in the very close observance of the margins of the shadows, even though the shadows are kept down to one tone, as variety of tone is not here demanded.

The effort in this drawing plate should be to secure action with the fewest possible lines, but do not attempt to put into practice facts or theories that have previously been learned, as opportunity to do that will come later. After rendering the form in this simple manner and simply suggesting the shadows on the face, spray the drawing with fixative, insert name, date, and class letter and number in their usual places, and send the plate in for criticism.

PLATE II

3. In this plate lay out the drawing as before, carry it to a more completed outline, and attempt somewhat to model the parts with a free use of the crayon and a sparing use of the stomp. The crayon should be rather sharp at first, although no attempt should be made to render the general lines with pencil-like fineness. The length of the panel, 17 inches, should be divided into eight equal parts, the upper one containing the head from the crown to the chin, the lower one marking the limit of the toes. The figure is somewhat less than eight heads in height, but appears tall on account of its height above the eye. The head, however, is not thrown so far back as in the previous case, and although the under side of the brows and nose as well as the chin are distinctly visible, none of these features become as foreshortened as those in Plate I.

The figure is turned somewhat away from the eye, and the weight, though thrown on the right leg as before, causes the body to sag somewhat so that the breasts are not on the same line. The figure being of a rather thin person shows the prominences and depressions rather clearly; the lines are angular and in no place show the full curves of maturity and therefore forms a good subject for study. In locating points of prominence, attention is called to the shoulders, the elbows, the prominence in the upper part of the hips, the knees, and the heels. Broad, sweeping lines lightly drawn should connect these points when properly located. The general head-lengths will indicate approximately only the general positions of the breasts, navel, and pubes.

Drawn by CHAS. A. PULCIFER

Drawn by MELVIN NICHOLS

Observe that while none of the lines in this figure are absolutely straight, none possess a continuous curve. The model's left shoulder starts nearly horizontally across the chest, but the horizontal line marking the line of the collar bone is depressed at each end and high in the middle. The opposite shoulder is composed of a series of flattened curves that disappear behind the upturned arm, and from the shoulder to the neck a series of curves prevents the general contour from appearing stiff and monotonous. Do not attempt to run one set of lines into another, but rather let them join in flattened angles that may afterwards be rounded into graceful curves.

In modeling this figure lean to the lightest of flat tints. Commence with the head, and carefully render the hair, the shade under the eyes, nose, and upper lip in a light, even tone, and indicate the shadow cast on the neck, under the lower lip, and on the left cheek. The shadow may be deepened in some places by an additional touch of the crayon where emphasis is required, or by a delicate manipulation of the stomp. Do not use the stomp, however, where the effect can be obtained without it. About the eyes and in the recesses of the hair this instrument may be necessary, but in open spaces light touches of the crayon pencil will give better results. The shadows on the side of the trunk and under the breasts should be rendered with the crayon, touched so lightly to the paper as to barely leave a mark. The modeling of the entire figure should be suggested, rather than finished.

The points to be particularly noted in the rendering are the depression in the left kneecap, the ankle bone, and the position in which the model is posed so that it throws the weight of the body forwards and causes a prominence of the muscle in the right thigh as well as a certain fulness in the shin. The backward pressure of the left leg calls the thigh muscles into action; first, just above the knee, where most of the strain comes, and after, farther up on the inside of the leg. The calf of the left leg is rounded and full—also suggestive of this pressure—and the entire trend of the

modeling should be to express this action with the fewest possible lines. Here the right foot is seen in profile, and the left foot is sharply foreshortened and nearly on a level with the eye.

After completing this modeling, spray it, and insert name, date, etc. in their usual places; then send the plate in for correction. _____

PLATE III

4. In Plate III, the modeling is carried to a somewhat more completed condition than in the previous example. The details of the face have been softened one into the other by means of the point of the stomp, touched lightly here and there to remove the darker color and to blend off the lighter shade where the planes of shadow fade into one another. The hair, although indicated in masses, possesses no detail, but a few strongly placed shadows assist in bringing its main features into prominence. The position of the arms throws the shoulders rather squarely across, and the clasped hands cause the muscles of the forearm to swell into prominence near the elbow. The raising of the shoulders in this position also draws out the waist and causes a hollow appearance at the elbows, while the weight of the body on the right leg throws the pelvis on that side in a higher position, showing a prominence of the bone above on a level with the navel and a prominence of the thigh muscle immediately below it. The fulness from the thigh to the knee is caused by the strain on the right leg; also, the fulness of the shin muscle, as in the last figure. Here the kneecaps and knee joint are clearly defined, and in the outside of the left leg there is a depression above the kneecap similar to that referred to in the previous figure.

These points must be taken in and considered before the first laying in is attempted, and the figure carefully modeled to form by a series of light but broad lines indicating the general planes of shade. Be careful, in doing this, not to encroach on the planes of light, which must be left clear, no attempt being made to blend them off very delicately. The

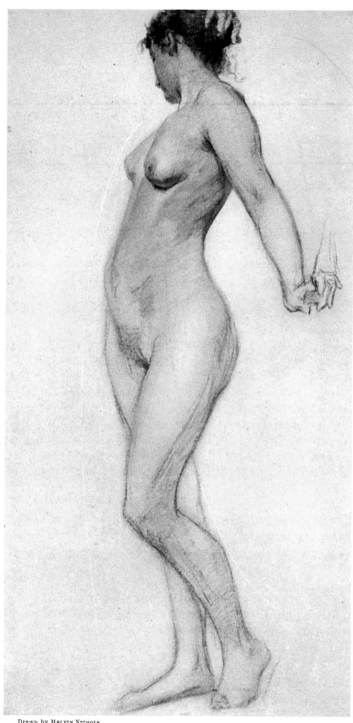

Drawn by MELVIN NICHOLS

planes of shadow on the outsides of the arms express the muscles drawn into action, and the deep shadows under the clasped hands and the elbows cause the body to appear to recede at that point and give it the proper roundness and other characteristics.

This plate, after being carefully drawn according to instructions, should be sprayed with fixative; then the student's name, the date, and class letter and number should be inserted in their usual places, and the work sent in for correction.

PLATE IV

5. In this figure the pose is selected to show the beautiful curve in the back, as well as the profile of the breast and the upper portion of the body. The general direction of the left leg gives the line of support and we have the relative points of prominence in this member as seen from behind to compare with the relative points of prominence studied in connection with the previous plates. The outside of the thigh in the right leg is slightly convex, while the corresponding line on the inside of the thigh has a tendency to be concave. The positions of the feet govern the appearance and points of prominence of the leg. In the left leg the foot rests at an angle, but in the right leg the foot is turned in profile and is flat on the floor, thus changing the contours accordingly. From the back of the neck to the hollow of the back is an even, graceful, convex curve. At the back it becomes concave and swells again to the thigh. The left arm, extending to the ring that is grasped by the hand, exhibits some of its muscles in prominence. Here the triceps swell out to form a tangential union with the curve from the back of the neck to the back of the body. The muscles of the forearm are necessarily prominent, owing to the weight that is thrown on the wrist. The fulness of the chest is shown above the left breast, and a nearly straight line extends from the under side of the right breast to the navel.

In modeling, all the shadows in the upper part of this figure should be first expressed with lines, graded afterwards

with the stomp and worked over again in lines with the crayon point to give transparency. The right hand appears over the top of the head, the entire arm being lost on the other side of the figure.

Great care must be exercised in drawing the lines of the neck in this figure in order not to present a distorted or unnatural appearance. The figure is posed above the eye, so that the under side of the chin and tip of the nose are barely visible. The head is turned so far away that the socket of the eye is scarcely expressed. The endeavor of the student in rendering this figure should be to express the head with a few masses of light and shadow, rather than by outlining in detail. The deepest shadows are under the left breast and in the hollow of the back, but rapidly blend off into the middle tone.

On this plate we have the first suggestion of delicate modeling, but no attempt should be made to carry the modeling farther than indicated on this drawing plate. We are still working for outlines of mass, and farther than this the work should not be carried.

After completing this drawing, it should be carefully sprayed with fixative; then insert the name, date, and class letter and number in their usual places, and send the plate in for correction.

PLATE V

6. In this plate we have a good example of a completely modeled figure. The outlines are cleanly cut, the shadows are softly blended, and the whole drawing is rendered to give a finished effect of light and shade as it existed in the original. Note, however, that no matter how dark the deepest shadows may appear, they possess a transparency free from all muddiness.

The body rests as before on the right leg, throwing the right hip somewhat above its normal position. The back of the right hand rests above the hip, causing a depression of the flesh at this point, and the line of the upper portion of the body should be nearly straight from the arm to the

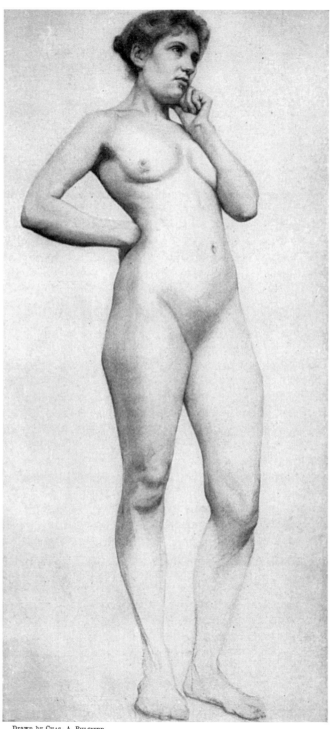

Drawn by Chas. A. Pulcifer

intersection of the wrist and the waist. This line is not straight, however; it is concave at the beginning and ending and convex in the middle, because of the prominence of the muscles of the back. The muscles of the forearm are rather full, but neither the upper arm nor the forearm are perfectly straight but are slightly curved. The convexity of the upper arm and the concave sides of the inside of the arm consist of a number of delicate curves and not one even curve.

Note carefully the lines bounding the planes of shadow down the entire right side of the body, and that these planes fade into the high light on the front of the abdomen. The accented shadow under the breast outlines this feature, while the opposite breast is crushed into the forearm, causing a depression in the left forearm from the wrist half way to the elbow. This must be carefully rendered in order to prevent a distorted appearance in the left arm.

The line from the intersection of the body with the left arm to the prominence of the thigh, appears at first to be composed of two concave curves with one convex curve between them. Careful study, however, will show that between the convexity of the abdomen and the prominence of the thigh, the line is rather convex and not flat. The knee on the right leg is sharply defined, and the fulness back of the knee is decidedly prominent. The right leg is in full front view, showing the points of prominence on the inside and outside of the calf, the fulness of the ankle bone, and the general trend to concavity from the pubes to the ankle bone caused by the curvature of the bones in this member.

The modeling on this plate is completed almost entirely by the use of the stomp. The shadows, being generally placed and their planes well defined, should be blended off softly into the high lights by gentle touches with the end of the stomp, the deeper shadows being added and worked in with the smaller stomp where required. Where the contours of the muscles are to be emphasized—as in the knuckle, under side of the right arm, and about the knees—careful touches of the crayon-charged stomp will express the planes and can afterwards be flattened off into the surrounding

planes where required. Close study must be given to the
face in order to locate satisfactorily the foreshortened fea-
tures and the planes of shadow that express them. It is not
important, however, that the student should be able to work
these details up as carefully as those on the original plate,
as drawings from the face can readily be made from the
living model, and it is better to study these features from life.

PLATE VI

7. In this plate we have the smooth, unbroken outlines
characteristic of the female figure. The oval-shaped head
thrown somewhat forwards, so that the under side of the
nose is lost, permits us to study the features under condi-
tions that have heretofore been described. Note that the
top of the head is plainly visible here, although the figure
is posed high in comparison with the level of the eye. The
right arm leaning against the hip is concave in its outer line,
although the concavity is expressed by a series of convex
curves. A line drawn through the center of the arm from
the shoulder to the elbow and from the elbow to the wrist,
will form two nearly equal concave curves about which the
contours of the arm can be expressed. A median line drawn
from the pit of the throat to the center of the body, to the
pubes, and thence straight to the center of the heel of the
right foot, will form the line of support. About this line
the right leg can be constructed, from the pubes to the knee
being nearly straight, whereas from the outside of the knee
the thigh swells rapidly in a convex curve and again recedes
to meet the waist line.

The general line from the armpit to the knee on the left
side of the figure is nearly straight, but composed of a
series of convex and concave curves, which combine to give
variety and prevent monotony. The left leg being thrown
somewhat backwards is foreshortened from the knee to the
heel, whereas the weight of the body resting on the right
leg gives prominence to the right hip. Few muscles are
brought into prominence with the figure in this position.

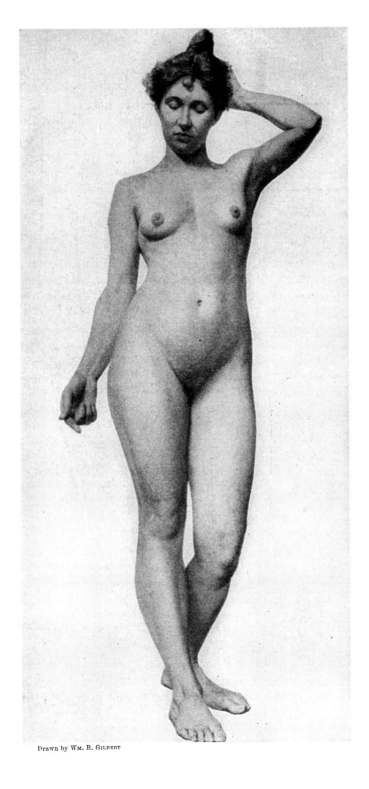

Drawn by Wm. B. Gilbert

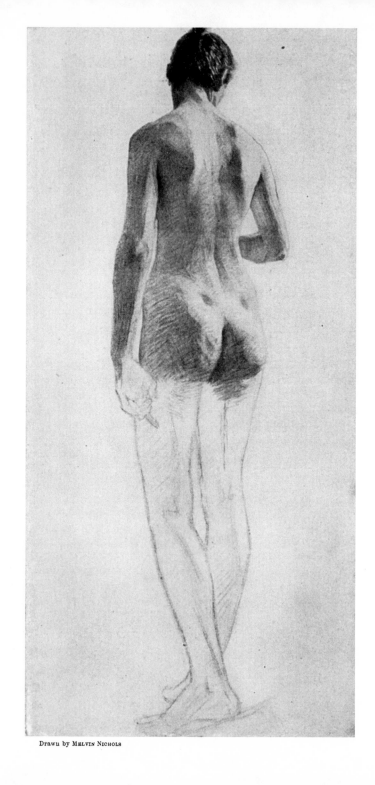

Drawn by MELVIN NICHOLS

except on the left shoulder and over the left breast. The shoulder muscle causes a depression between the neck and the arm itself, whereas on the right side the shoulder slopes off to the upper arm.

This figure is completed by carefully modeling with the stomp, and every effort should be made to give the shadows just that accentuation that would cause them to express roundness and depth of the individual parts in their proper places. The comparative size of the thigh and calf-in the female figure is well illustrated in this drawing. Careful study will show the influence of these points of prominence in the draped figure. _____

PLATE VII

8. Here we are shown the general appearance of the male figure when viewed from behind. The shadows are strongly marked, showing the prominence of the shoulder blades and the relative positions of the elbows and waist line as pointed out in previous photographic illustrations. Note the depressions just above the buttocks on each side of the spine, and also the general direction and curve of the spine, as expressed by a series of varying shadows. This drawing should be rendered only as far as shown in order that the student may express his familiarity with the details of prominence as seen in this view, the modeling being of no importance at present. The work may be carried farther and modeled at some future time.

This figure being rather thin, the points of bony prominence are readily seen. The left elbow is clearly indicated by a plane of shadow and high light in the center of the arm, while the right elbow is brought into prominence by means of the position of the arm. The bony construction of the hips beneath the flesh is shown by the fulness on the right side of the figure above the buttocks, and the curve from this point to the broadest point of the hips and thence to the back of the knee is plainly indicated. It can be easily studied here how the line of the waist is affected by the position of the hip and the amount of fat thereon.

In this figure the weight is thrown on the right foot, as was the case in Plate VI, but the curve in the waist line here is much flatter than was the case on Plate VI, owing to the fact that in this example there is less flesh on the hips and consequently the line is straighter. It can readily be seen that, were the hips fuller, the fleshy portion would tend to cause them to appear higher and thereby emphasize this curve at the waist.

PLATE VIII

9. In this plate we have the male figure posed in such a manner that it brings the principal muscles of the upper portion of the body into prominence. This light, graceful figure is an admirable one for study, as the sweeping lines are not cut by excessive muscular development nor rounded off by fatty tissue. The median line from the pit of the throat to the navel is clearly marked and is of the greatest assistance in drawing, inasmuch as one can build about it the relative proportions of the figure. The use of the plumb-line will be of great value, as many points of prominence fall directly beneath other points. The lines of the shoulders and muscles of the arm are well developed and clean cut, and the modeling for the arms and legs need be but suggested in order to convey the most complete idea. Note the delicate modeling of the hip bones, the bony and muscular structures showing through the flesh.

The entire outline is made up of short, straight lines, as for instance in the right arm, from where it joins the shoulder to the inside of the elbow; and in the forearm, where the inside contour is composed of a series of short, broken, straight lines. Observe, too, the general curvature of the right leg, throwing the right foot well under the center of the body. The feet as sketched here appear abnormally large, but this is due to the fact that the figure is almost entirely above the eye and the feet are much nearer the point of view than any other portion.

In drawing this plate, work on it as a whole and do not attempt to finish any portion until the entire figure is blocked

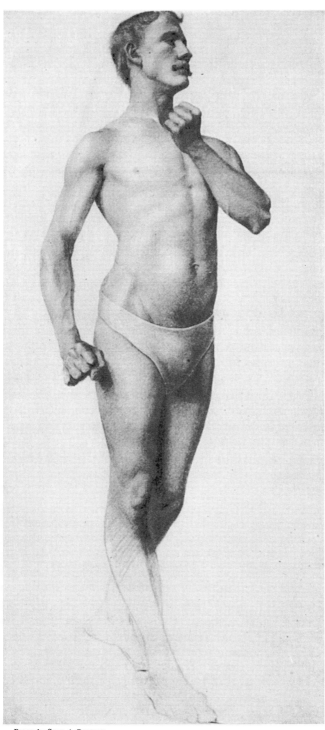

Drawn by CHAS. A. PULCIFER

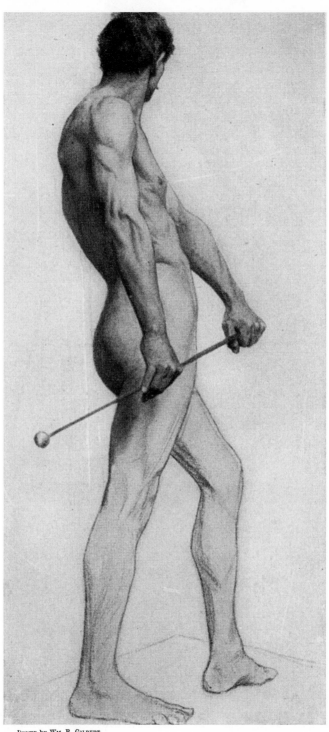

Drawn by WM. B. GILBERT

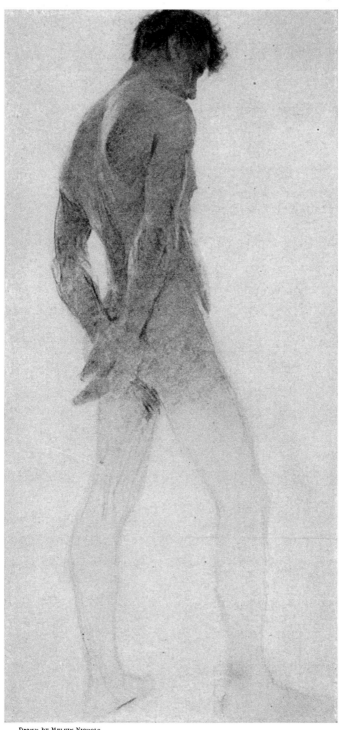

Drawn by MELVIN NICHOLS

in. Then model with the stomp and crayon until the round-ness of the parts is well expressed, and spray the drawing as usual before sending it in for correction.

PLATE IX

10. The interest in this pose is centered in the head and right arm, the muscles of the neck giving a clear idea of the effect of turning the head, while the muscles of the arm are thrown into prominence by the pose of the figure. The left shoulder appears considerably below the right owing to the fact that the figure is seen from below. The hands are well worthy of study, as the knuckles catch the light and form points that must be carefully located in order to preserve the proper construction. While the front of the body is mainly composed of a single sweep from the neck to the ankle, analysis of it will show that it consists of a series of convex lines subtly joined to one another so as to mark prominences due to muscular development. The deep shadow on the back contrasted with the high light on the upper arm, and the darkened hands profiled against the high light of the hip, tend to throw the right arm into prominence and give the figure a feeling of depth and solidity.

PLATE X

11. This plate gives an idea of the simplest form of modeling. The hands clasped behind the back are simply indicated, and in this position give considerable prominence to the shoulder blades. There is no attempt at variety of tone here, except where the high lights fall on the shoulders and elbows. The hair is increased in tone somewhat in order to contrast with the flesh, and a few strong lines are placed throughout the figure in order to express the direction of the planes. Although the hands are incomplete and roughly blocked, their position and pose can be readily felt, and this shows the importance of expressing details well in mass. In the legs there is no attempt at precision of outline, yet they are drawn in with a bold, free sweep that shows the

artist had a definite idea of points of start and arrival; the position and direction of each line was determined before the crayon was placed to the paper. For instance, at the juncture of the right thigh with the abdomen a point of start was established and the line sweeps boldly and freely to the knee, which is the definite point of finish, or arrival; and from here to a point above the instep another line is boldly drawn. Similar points can be found on all the parts of the figure, showing that the mind grasped the problem and the hand executed the work with mutual understanding.

It will be difficult for the beginner to determine these points of start and arrival at first, but he must not be discouraged should it be necessary for him to make the attempt a dozen or more times before striking the exact trend. Practice and study, however, will enable him to improve from time to time, and this method of procedure will instil into his drawings that feeling of action that is so important in all figure work.

PLATE XI

12. Plate XI is another example of simple modeling where most of the figure is expressed in monotone with a few high lights placed to give modeling and an occasional deeper shadow to emphasize the form. Note how transparent the shadow is throughout the back. There is no feeling of deadness there, but simply of partial shade. Close the eyes slightly, and the planes of light and shade become very strongly marked. Study these planes of light and shade carefully and endeavor to outline them before the shadow tone is placed on the drawing. Be careful not to overwork the shadow to make it too dark, and where two shaded portions are in contact observe the placing of the high lights in the deeper shadows in order to emphasize the outline. For instance, where the right hand is placed in the hollow of the back it is rendered in practically the same tone as the back itself, but the small high light on the upper part of the hand and the deepening shadow under the wrist, gives it outline and permits it to contrast with the tone

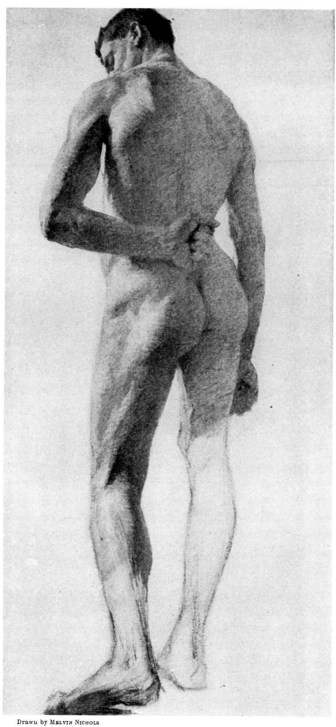

Drawn by MELVIN NICHOLS

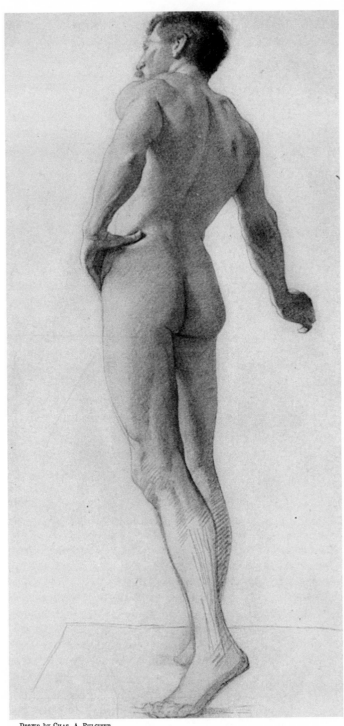

Drawn by CHAS. A. PULCIFER

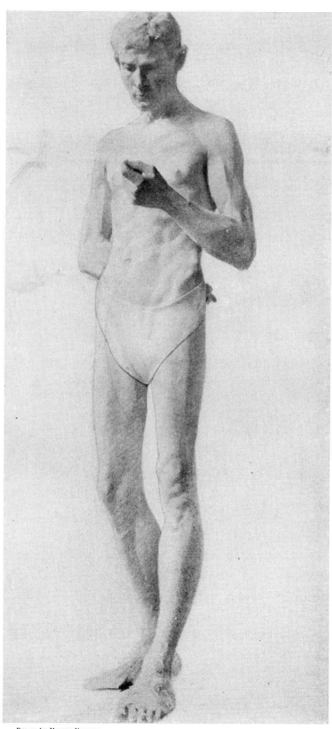

Drawn by MELVIN NICHOLS

against which it is placed. The upper side of the thumb, however, receives no high light, and as a matter of fact merges into the shadow of the back; but the eye feels the presence of its outline, as also of the ends of the knuckles, yet all that is placed here to convey that impression is the simple shading between the fingers. The whole solidity of this figure is based on a keen sense of light and shade and a clear understanding of where one begins and the other ends.

PLATE XII

13. The point of interest in this figure lies in the study of the foreshortening. The eye of the artist was about on a level with the ankle of the model, and as the figure leans slightly forwards, parts of it are materially foreshortened. The left elbow becomes very prominent, while the forearm tapers rapidly to the wrist owing to the fact that it is more distant. The right arm is similarly drawn, the taper of the muscles of the elbow to the wrist being even more conspicuous here. Note the vigorous treatment of the outlines where a series of simple lines block out the general form. The high light under the left arm tends to throw the left arm into the foreground apparently and increase the effect of foreshortening. The lines across the shoulders and hips are at such an angle that one readily feels the height of the figure above the eye. In rendering this figure, close attention should be given to the contrasting of high lights and shadows as well as to the blending of subtle variations, one into another.

PLATE XIII

14. Plate XIII shows the figure of a rather thin person, and though the bones are well covered with muscles there is not much prominence given to any one set, nor any development of fat. The lines, however, remain practically the same as those of a muscular figure, but not so prominent. The modeling is carried out with great nicety, and the effect of contrast between light and shade in order to give

foreshortening in perspective is well studied. There is not
a great variety of tone here, and the simplicity with which
the effect is obtained is readily illustrated in the plane of
shadow that extends the full length of the left leg, particu-
larly the part of the leg from the knee to the ankle. The
union or intersection of this plane of shadow with the plane
of light marks the intersection with the shin bone, while the
contrast of the pale light with the deepest shadow on the
right leg gives the full contour of the left foreleg, without
individual outline. The enormous size of the left foot is
due to the fact that it is thrust well forwards and is much
nearer the eye than the rest of the figure. The careful
modeling of the hand and the deep shadow on its under side
tend to throw it well forwards of the high light on the chest;
and the muscles of the chest and abdomen, though but
slightly expressed, all make their appearance felt, although
the outlines are very elusive.

REMARKS

15. In drawing these figures for practice do not endeavor
to copy them line for line and shade for shade, but study
them with a view to learning what details must necessarily
be represented and how such details can best be represented
by means of light-and-shade values. These drawings were
made from the living model, and the copying of the draw-
ings themselves will not be of the same value as the making
of drawings from a model. Small sections of them should
be taken from time to time and drawn in crayon, using the
stomp for the modeling. The crayon may be used as a
pencil, or a portion of it may be scraped to a powder and
the stomp dipped in it and then applied to the paper.
Only the lightest and most delicate treatment should be
attempted, as hard rubbing with the stomp produces a dull
and dirty looking surface. Where a detail can be expressed
with one or two lines, it should be so drawn, and not over-
worked with more lines.

After drawing a complete figure or a portion of a figure it

is excellent practice to attempt to redraw the same from memory without any copy before the eye, reverting to the copy only for such details as cannot be remembered. Training of this character enables the mind to carry a mental idea of what is to be represented, and is of great assistance in drawing from life, inasmuch as after studying the pose or figure the hand can be readily directed to execute its main outlines without the eye constantly returning to the original.

Study from life in the draped figure is quite as important as study from the nude, but the artist must ever bear in mind that draped forms depend for their outline and appearance on the form within, and the position of the arms and legs will in all instances have more or less influence on the direction and character of the folds of the drapery. In fact, the expression of folds in drapery should be of such a character as to convey the feeling of support and structure within, and in drawing from the draped figure the artist should always endeavor to mentally account for the direction and cause of every fold he depicts and not place them at random simply because he thinks he sees them in a certain position. Care in studying these details is important in the training of the mind to grasp the situation quickly and enable the hand to make a sketched memorandum in a comparatively short space of time.

A CATALOG OF SELECTED
DOVER BOOKS
IN ALL FIELDS OF INTEREST

A CATALOG OF SELECTED DOVER
BOOKS IN ALL FIELDS OF INTEREST

CONCERNING THE SPIRITUAL IN ART, Wassily Kandinsky. Pioneering work by father of abstract art. Thoughts on color theory, nature of art. Analysis of earlier masters. 12 illustrations. 80pp. of text. 5⅜ x 8½. 0-486-23411-8

CELTIC ART: The Methods of Construction, George Bain. Simple geometric techniques for making Celtic interlacements, spirals, Kells-type initials, animals, humans, etc. Over 500 illustrations. 160pp. 9 x 12. (Available in U.S. only.) 0-486-22923-8

AN ATLAS OF ANATOMY FOR ARTISTS, Fritz Schider. Most thorough reference work on art anatomy in the world. Hundreds of illustrations, including selections from works by Vesalius, Leonardo, Goya, Ingres, Michelangelo, others. 593 illustrations. 192pp. 7⅛ x 10¼. 0-486-20241-0

CELTIC HAND STROKE-BY-STROKE (Irish Half-Uncial from "The Book of Kells"): An Arthur Baker Calligraphy Manual, Arthur Baker. Complete guide to creating each letter of the alphabet in distinctive Celtic manner. Covers hand position, strokes, pens, inks, paper, more. Illustrated. 48pp. 8¼ x 11. 0-486-24336-2

EASY ORIGAMI, John Montroll. Charming collection of 32 projects (hat, cup, pelican, piano, swan, many more) specially designed for the novice origami hobbyist. Clearly illustrated easy-to-follow instructions insure that even beginning papercrafters will achieve successful results. 48pp. 8¼ x 11. 0-486-27298-2

BLOOMINGDALE'S ILLUSTRATED 1886 CATALOG: Fashions, Dry Goods and Housewares, Bloomingdale Brothers. Famed merchants' extremely rare catalog depicting about 1,700 products: clothing, housewares, firearms, dry goods, jewelry, more. Invaluable for dating, identifying vintage items. Also, copyright-free graphics for artists, designers. Co-published with Henry Ford Museum & Greenfield Village. 160pp. 8¼ x 11. 0-486-25780-0

THE ART OF WORLDLY WISDOM, Baltasar Gracian. "Think with the few and speak with the many," "Friends are a second existence," and "Be able to forget" are among this 1637 volume's 300 pithy maxims. A perfect source of mental and spiritual refreshment, it can be opened at random and appreciated either in brief or at length. 128pp. 5⅜ x 8½. 0-486-44034-6

JOHNSON'S DICTIONARY: A Modern Selection, Samuel Johnson (E. L. McAdam and George Milne, eds.). This modern version reduces the original 1755 edition's 2,300 pages of definitions and literary examples to a more manageable length, retaining the verbal pleasure and historical curiosity of the original. 480pp. 5³⁄₁₆ x 8¼. 0-486-44089-3

ADVENTURES OF HUCKLEBERRY FINN, Mark Twain, Illustrated by E. W. Kemble. A work of eternal richness and complexity, a source of ongoing critical debate, and a literary landmark, Twain's 1885 masterpiece about a barefoot boy's journey of self-discovery has enthralled readers around the world. This handsome clothbound reproduction of the first edition features all 174 of the original black-and-white illustrations. 368pp. 5⅜ x 8½. 0-486-44322-1

STICKLEY CRAFTSMAN FURNITURE CATALOGS, Gustav Stickley and L. & J. G. Stickley. Beautiful, functional furniture in two authentic catalogs from 1910. 594 illustrations, including 277 photos, show settles, rockers, armchairs, reclining chairs, bookcases, desks, tables. 183pp. 6½ x 9¼. 0-486-23838-5

AMERICAN LOCOMOTIVES IN HISTORIC PHOTOGRAPHS: 1858 to 1949, Ron Ziel (ed.). A rare collection of 126 meticulously detailed official photographs, called "builder portraits," of American locomotives that majestically chronicle the rise of steam locomotive power in America. Introduction. Detailed captions. xi+ 129pp. 9 x 12. 0-486-27393-8

AMERICA'S LIGHTHOUSES: An Illustrated History, Francis Ross Holland, Jr. Delightfully written, profusely illustrated fact-filled survey of over 200 American light-houses since 1716. History, anecdotes, technological advances, more. 240pp. 8 x 10¾.
0-486-25576-X

TOWARDS A NEW ARCHITECTURE, Le Corbusier. Pioneering manifesto by founder of "International School." Technical and aesthetic theories, views of industry, eco-nomics, relation of form to function, "mass-production split" and much more. Profusely illustrated. 320pp. 6⅛ x 9¼. (Available in U.S. only.) 0-486-25023-7

HOW THE OTHER HALF LIVES, Jacob Riis. Famous journalistic record, expos-ing poverty and degradation of New York slums around 1900, by major social reformer. 100 striking and influential photographs. 233pp. 10 x 7⅞. 0-486-22012-5

FRUIT KEY AND TWIG KEY TO TREES AND SHRUBS, William M. Harlow. One of the handiest and most widely used identification aids. Fruit key covers 120 deciduous and evergreen species; twig key 160 deciduous species. Easily used. Over 300 photographs. 126pp. 5⅜ x 8½. 0-486-20511-8

COMMON BIRD SONGS, Dr. Donald J. Borror. Songs of 60 most common U.S. birds: robins, sparrows, cardinals, bluejays, finches, more–arranged in order of increasing complexity. Up to 9 variations of songs of each species.
Cassette and manual 0-486-99911-4

ORCHIDS AS HOUSE PLANTS, Rebecca Tyson Northen. Grow cattleyas and many other kinds of orchids–in a window, in a case, or under artificial light. 63 illus-trations. 148pp. 5⅜ x 8½. 0-486-23261-1

MONSTER MAZES, Dave Phillips. Masterful mazes at four levels of difficulty. Avoid deadly perils and evil creatures to find magical treasures. Solutions for all 32 exciting illustrated puzzles. 48pp. 8¼ x 11. 0-486-26005-4

MOZART'S DON GIOVANNI (DOVER OPERA LIBRETTO SERIES), Wolfgang Amadeus Mozart. Introduced and translated by Ellen H. Bleiler. Standard Italian libretto, with complete English translation. Convenient and thoroughly portable–an ideal companion for reading along with a recording or the performance itself. Introduction. List of characters. Plot summary. 121pp. 5¼ x 8½. 0-486-24944-1

FRANK LLOYD WRIGHT'S DANA HOUSE, Donald Hoffmann. Pictorial essay of residential masterpiece with over 160 interior and exterior photos, plans, eleva-tions, sketches and studies. 128pp. 9¼ x 10¾. 0-486-29120-0

THE CLARINET AND CLARINET PLAYING, David Pino. Lively, comprehensive work features suggestions about technique, musicianship, and musical interpretation, as well as guidelines for teaching, making your own reeds, and preparing for public performance. Includes an intriguing look at clarinet history. "A godsend," *The Clarinet,* Journal of the International Clarinet Society. Appendixes. 7 illus. 320pp. 5⅜ x 8½. 0-486-40270-3

HOLLYWOOD GLAMOR PORTRAITS, John Kobal (ed.). 145 photos from 1926-49. Harlow, Gable, Bogart, Bacall; 94 stars in all. Full background on photographers, technical aspects. 160pp. 8⅜ x 11¼. 0-486-23352-9

THE RAVEN AND OTHER FAVORITE POEMS, Edgar Allan Poe. Over 40 of the author's most memorable poems: "The Bells," "Ulalume," "Israfel," "To Helen," "The Conqueror Worm," "Eldorado," "Annabel Lee," many more. Alphabetic lists of titles and first lines. 64pp. 5⁵⁄₁₆ x 8¼. 0-486-26685-0

PERSONAL MEMOIRS OF U. S. GRANT, Ulysses Simpson Grant. Intelligent, deeply moving firsthand account of Civil War campaigns, considered by many the finest military memoirs ever written. Includes letters, historic photographs, maps and more. 528pp. 6⅛ x 9¼. 0-486-28587-1

ANCIENT EGYPTIAN MATERIALS AND INDUSTRIES, A. Lucas and J. Harris. Fascinating, comprehensive, thoroughly documented text describes this ancient civilization's vast resources and the processes that incorporated them in daily life, including the use of animal products, building materials, cosmetics, perfumes and incense, fibers, glazed ware, glass and its manufacture, materials used in the mummification process, and much more. 544pp. 6⅛ x 9¼. (Available in U.S. only.) 0-486-40446-3

RUSSIAN STORIES/RUSSKIE RASSKAZY: A Dual-Language Book, edited by Gleb Struve. Twelve tales by such masters as Chekhov, Tolstoy, Dostoevsky, Pushkin, others. Excellent word-for-word English translations on facing pages, plus teaching and study aids, Russian/English vocabulary, biographical/critical introductions, more. 416pp. 5⅜ x 8½. 0-486-26244-8

PHILADELPHIA THEN AND NOW: 60 Sites Photographed in the Past and Present, Kenneth Finkel and Susan Oyama. Rare photographs of City Hall, Logan Square, Independence Hall, Betsy Ross House, other landmarks juxtaposed with contemporary views. Captures changing face of historic city. Introduction. Captions. 128pp. 8¼ x 11. 0-486-25790-8

NORTH AMERICAN INDIAN LIFE: Customs and Traditions of 23 Tribes, Elsie Clews Parsons (ed.). 27 fictionalized essays by noted anthropologists examine religion, customs, government, additional facets of life among the Winnebago, Crow, Zuni, Eskimo, other tribes. 480pp. 6⅛ x 9¼. 0-486-27377-6

TECHNICAL MANUAL AND DICTIONARY OF CLASSICAL BALLET, Gail Grant. Defines, explains, comments on steps, movements, poses and concepts. 15-page pictorial section. Basic book for student, viewer. 127pp. 5⅜ x 8½. 0-486-21843-0

THE MALE AND FEMALE FIGURE IN MOTION: 60 Classic Photographic Sequences, Eadweard Muybridge. 60 true-action photographs of men and women walking, running, climbing, bending, turning, etc., reproduced from rare 19th-century masterpiece. vi + 121pp. 9 x 12. 0-486-24745-7

ANIMALS: 1,419 Copyright-Free Illustrations of Mammals, Birds, Fish, Insects, etc., Jim Harter (ed.). Clear wood engravings present, in extremely lifelike poses, over 1,000 species of animals. One of the most extensive pictorial sourcebooks of its kind. Captions. Index. 284pp. 9 x 12. 0-486-23766-4

1001 QUESTIONS ANSWERED ABOUT THE SEASHORE, N. J. Berrill and Jacquelyn Berrill. Queries answered about dolphins, sea snails, sponges, starfish, fishes, shore birds, many others. Covers appearance, breeding, growth, feeding, much more. 305pp. 5¼ x 8¼. 0-486-23366-9

ATTRACTING BIRDS TO YOUR YARD, William J. Weber. Easy-to-follow guide offers advice on how to attract the greatest diversity of birds: birdhouses, feeders, water and waterers, much more. 96pp. 5³⁄₁₆ x 8¼. 0-486-28927-3

MEDICINAL AND OTHER USES OF NORTH AMERICAN PLANTS: A Historical Survey with Special Reference to the Eastern Indian Tribes, Charlotte Erichsen-Brown. Chronological historical citations document 500 years of usage of plants, trees, shrubs native to eastern Canada, northeastern U.S. Also complete identifying information. 343 illustrations. 544pp. 6½ x 9¼. 0-486-25951-X

STORYBOOK MAZES, Dave Phillips. 23 stories and mazes on two-page spreads: Wizard of Oz, Treasure Island, Robin Hood, etc. Solutions. 64pp. 8¼ x 11.
 0-486-23628-5

AMERICAN NEGRO SONGS: 230 Folk Songs and Spirituals, Religious and Secular, John W. Work. This authoritative study traces the African influences of songs sung and played by black Americans at work, in church, and as entertainment. The author discusses the lyric significance of such songs as "Swing Low, Sweet Chariot," "John Henry," and others and offers the words and music for 230 songs. Bibliography. Index of Song Titles. 272pp. 6½ x 9¼. 0-486-40271-1

MOVIE-STAR PORTRAITS OF THE FORTIES, John Kobal (ed.). 163 glamor, studio photos of 106 stars of the 1940s: Rita Hayworth, Ava Gardner, Marlon Brando, Clark Gable, many more. 176pp. 8⅜ x 11¼. 0-486-23546-7

YEKL and THE IMPORTED BRIDEGROOM AND OTHER STORIES OF YIDDISH NEW YORK, Abraham Cahan. Film Hester Street based on *Yekl* (1896). Novel, other stories among first about Jewish immigrants on N.Y.'s East Side. 240pp. 5⅜ x 8½. 0-486-22427-9

SELECTED POEMS, Walt Whitman. Generous sampling from *Leaves of Grass*. Twenty-four poems include "I Hear America Singing," "Song of the Open Road," "I Sing the Body Electric," "When Lilacs Last in the Dooryard Bloom'd," "O Captain! My Captain!"–all reprinted from an authoritative edition. Lists of titles and first lines. 128pp. 5³⁄₁₆ x 8¼. 0-486-26878-0

SONGS OF EXPERIENCE: Facsimile Reproduction with 26 Plates in Full Color, William Blake. 26 full-color plates from a rare 1826 edition. Includes "The Tyger," "London," "Holy Thursday," and other poems. Printed text of poems. 48pp. 5¼ x 7.
 0-486-24636-1

THE BEST TALES OF HOFFMANN, E. T. A. Hoffmann. 10 of Hoffmann's most important stories: "Nutcracker and the King of Mice," "The Golden Flowerpot," etc. 458pp. 5⅜ x 8½. 0-486-21793-0

THE BOOK OF TEA, Kakuzo Okakura. Minor classic of the Orient: entertaining, charming explanation, interpretation of traditional Japanese culture in terms of tea ceremony. 94pp. 5⅜ x 8½. 0-486-20070-1

FRENCH STORIES/CONTES FRANÇAIS: A Dual-Language Book, Wallace Fowlie. Ten stories by French masters, Voltaire to Camus: "Micromegas" by Voltaire; "The Atheist's Mass" by Balzac; "Minuet" by de Maupassant; "The Guest" by Camus, six more. Excellent English translations on facing pages. Also French-English vocabulary list, exercises, more. 352pp. 5⅜ x 8½. 0-486-26443-2

CHICAGO AT THE TURN OF THE CENTURY IN PHOTOGRAPHS: 122 Historic Views from the Collections of the Chicago Historical Society, Larry A. Viskochil. Rare large-format prints offer detailed views of City Hall, State Street, the Loop, Hull House, Union Station, many other landmarks, circa 1904-1913. Introduction. Captions. Maps. 144pp. 9⅜ x 12¼. 0-486-24656-6

OLD BROOKLYN IN EARLY PHOTOGRAPHS, 1865-1929, William Lee Younger. Luna Park, Gravesend race track, construction of Grand Army Plaza, moving of Hotel Brighton, etc. 157 previously unpublished photographs. 165pp. 8⅜ x 11¾. 0-486-23587-4

THE MYTHS OF THE NORTH AMERICAN INDIANS, Lewis Spence. Rich anthology of the myths and legends of the Algonquins, Iroquois, Pawnees and Sioux, prefaced by an extensive historical and ethnological commentary. 36 illustrations. 480pp. 5⅜ x 8½. 0-486-25967-6

AN ENCYCLOPEDIA OF BATTLES: Accounts of Over 1,560 Battles from 1479 B.C. to the Present, David Eggenberger. Essential details of every major battle in recorded history from the first battle of Megiddo in 1479 B.C. to Grenada in 1984. List of Battle Maps. New Appendix covering the years 1967-1984. Index. 99 illustrations. 544pp. 6½ x 9¼. 0-486-24913-1

SAILING ALONE AROUND THE WORLD, Captain Joshua Slocum. First man to sail around the world, alone, in small boat. One of great feats of seamanship told in delightful manner. 67 illustrations. 294pp. 5⅜ x 8½. 0-486-20326-3

ANARCHISM AND OTHER ESSAYS, Emma Goldman. Powerful, penetrating, prophetic essays on direct action, role of minorities, prison reform, puritan hypocrisy, violence, etc. 271pp. 5⅜ x 8½. 0-486-22484-8

MYTHS OF THE HINDUS AND BUDDHISTS, Ananda K. Coomaraswamy and Sister Nivedita. Great stories of the epics; deeds of Krishna, Shiva, taken from puranas, Vedas, folk tales; etc. 32 illustrations. 400pp. 5⅜ x 8½. 0-486-21759-0

MY BONDAGE AND MY FREEDOM, Frederick Douglass. Born a slave, Douglass became outspoken force in antislavery movement. The best of Douglass' autobiographies. Graphic description of slave life. 464pp. 5⅜ x 8½. 0-486-22457-0

FOLLOWING THE EQUATOR: A Journey Around the World, Mark Twain. Fascinating humorous account of 1897 voyage to Hawaii, Australia, India, New Zealand, etc. Ironic, bemused reports on peoples, customs, climate, flora and fauna, politics, much more. 197 illustrations. 720pp. 5⅜ x 8½. 0-486-26113-1

THE PEOPLE CALLED SHAKERS, Edward D. Andrews. Definitive study of Shakers: origins, beliefs, practices, dances, social organization, furniture and crafts, etc. 33 illustrations. 351pp. 5⅜ x 8½. 0-486-21081-2

THE MYTHS OF GREECE AND ROME, H. A. Guerber. A classic of mythology, generously illustrated, long prized for its simple, graphic, accurate retelling of the principal myths of Greece and Rome, and for its commentary on their origins and significance. With 64 illustrations by Michelangelo, Raphael, Titian, Rubens, Canova, Bernini and others. 480pp. 5⅜ x 8½. 0-486-27584-1

PSYCHOLOGY OF MUSIC, Carl E. Seashore. Classic work discusses music as a medium from psychological viewpoint. Clear treatment of physical acoustics, auditory apparatus, sound perception, development of musical skills, nature of musical feeling, host of other topics. 88 figures. 408pp. 5⅜ x 8½. 0-486-21851-1

LIFE IN ANCIENT EGYPT, Adolf Erman. Fullest, most thorough, detailed older account with much not in more recent books, domestic life, religion, magic, medicine, commerce, much more. Many illustrations reproduce tomb paintings, carvings, hieroglyphs, etc. 597pp. 5⅜ x 8½. 0-486-22632-8

SUNDIALS, Their Theory and Construction, Albert Waugh. Far and away the best, most thorough coverage of ideas, mathematics concerned, types, construction, adjusting anywhere. Simple, nontechnical treatment allows even children to build several of these dials. Over 100 illustrations. 230pp. 5⅜ x 8½. 0-486-22947-5

THEORETICAL HYDRODYNAMICS, L. M. Milne-Thomson. Classic exposition of the mathematical theory of fluid motion, applicable to both hydrodynamics and aerodynamics. Over 600 exercises. 768pp. 6⅛ x 9¼. 0-486-68970-0

OLD-TIME VIGNETTES IN FULL COLOR, Carol Belanger Grafton (ed.). Over 390 charming, often sentimental illustrations, selected from archives of Victorian graphics—pretty women posing, children playing, food, flowers, kittens and puppies, smiling cherubs, birds and butterflies, much more. All copyright-free. 48pp. 9¼ x 12¼. 0-486-27269-9

PERSPECTIVE FOR ARTISTS, Rex Vicat Cole. Depth, perspective of sky and sea, shadows, much more, not usually covered. 391 diagrams, 81 reproductions of drawings and paintings. 279pp. 5⅜ x 8½. 0-486-22487-2

DRAWING THE LIVING FIGURE, Joseph Sheppard. Innovative approach to artistic anatomy focuses on specifics of surface anatomy, rather than muscles and bones. Over 170 drawings of live models in front, back and side views, and in widely varying poses. Accompanying diagrams. 177 illustrations. Introduction. Index. 144pp. 8⅜ x 11¼. 0-486-26723-7

GOTHIC AND OLD ENGLISH ALPHABETS: 100 Complete Fonts, Dan X. Solo. Add power, elegance to posters, signs, other graphics with 100 stunning copyright-free alphabets: Blackstone, Dolbey, Germania, 97 more—including many lower-case, numerals, punctuation marks. 104pp. 8⅛ x 11. 0-486-24695-7

THE BOOK OF WOOD CARVING, Charles Marshall Sayers. Finest book for beginners discusses fundamentals and offers 34 designs. "Absolutely first rate . . . well thought out and well executed."–E. J. Tangerman. 118pp. 7¾ x 10⅝. 0-486-23654-4

ILLUSTRATED CATALOG OF CIVIL WAR MILITARY GOODS: Union Army Weapons, Insignia, Uniform Accessories, and Other Equipment, Schuyler, Hartley, and Graham. Rare, profusely illustrated 1846 catalog includes Union Army uniform and dress regulations, arms and ammunition, coats, insignia, flags, swords, rifles, etc. 226 illustrations. 160pp. 9 x 12. 0-486-24939-5

WOMEN'S FASHIONS OF THE EARLY 1900s: An Unabridged Republication of "New York Fashions, 1909," National Cloak & Suit Co. Rare catalog of mail-order fashions documents women's and children's clothing styles shortly after the turn of the century. Captions offer full descriptions, prices. Invaluable resource for fashion, costume historians. Approximately 725 illustrations. 128pp. 8⅜ x 11¼.

0-486-27276-1

HOW TO DO BEADWORK, Mary White. Fundamental book on craft from simple projects to five-bead chains and woven works. 106 illustrations. 142pp. 5⅜ x 8.
0-486-20697-1

THE 1912 AND 1915 GUSTAV STICKLEY FURNITURE CATALOGS, Gustav Stickley. With over 200 detailed illustrations and descriptions, these two catalogs are essential reading and reference materials and identification guides for Stickley furniture. Captions cite materials, dimensions and prices. 112pp. 6½ x 9¼. 0-486-26676-1

EARLY AMERICAN LOCOMOTIVES, John H. White, Jr. Finest locomotive engravings from early 19th century: historical (1804–74), main-line (after 1870), special, foreign, etc. 147 plates. 142pp. 11⅜ x 8¼.
0-486-22772-3

LITTLE BOOK OF EARLY AMERICAN CRAFTS AND TRADES, Peter Stockham (ed.). 1807 children's book explains crafts and trades: baker, hatter, cooper, potter, and many others. 23 copperplate illustrations. 140pp. 4⅝ x 6.
0-486-23336-7

VICTORIAN FASHIONS AND COSTUMES FROM HARPER'S BAZAR, 1867–1898, Stella Blum (ed.). Day costumes, evening wear, sports clothes, shoes, hats, other accessories in over 1,000 detailed engravings. 320pp. 9⅜ x 12¼.
0-486-22990-4

THE LONG ISLAND RAIL ROAD IN EARLY PHOTOGRAPHS, Ron Ziel. Over 220 rare photos, informative text document origin (1844) and development of rail service on Long Island. Vintage views of early trains, locomotives, stations, passengers, crews, much more. Captions. 8⅞ x 11¾. 0-486-26301-0

VOYAGE OF THE LIBERDADE, Joshua Slocum. Great 19th-century mariner's thrilling, first-hand account of the wreck of his ship off South America, the 35-foot boat he built from the wreckage, and its remarkable voyage home. 128pp. 5⅜ x 8½.
0-486-40022-0

TEN BOOKS ON ARCHITECTURE, Vitruvius. The most important book ever written on architecture. Early Roman aesthetics, technology, classical orders, site selection, all other aspects. Morgan translation. 331pp. 5⅜ x 8½. 0-486-20645-9

THE HUMAN FIGURE IN MOTION, Eadweard Muybridge. More than 4,500 stopped-action photos, in action series, showing undraped men, women, children jumping, lying down, throwing, sitting, wrestling, carrying, etc. 390pp. 7⅞ x 10⅝.
0-486-20204-6 Clothbd.

TREES OF THE EASTERN AND CENTRAL UNITED STATES AND CANADA, William M. Harlow. Best one-volume guide to 140 trees. Full descriptions, woodlore, range, etc. Over 600 illustrations. Handy size. 288pp. 4½ x 6⅜. 0-486-20395-6

GROWING AND USING HERBS AND SPICES, Milo Miloradovich. Versatile handbook provides all the information needed for cultivation and use of all the herbs and spices available in North America. 4 illustrations. Index. Glossary. 236pp. 5⅜ x 8½.
0-486-25058-X

BIG BOOK OF MAZES AND LABYRINTHS, Walter Shepherd. 50 mazes and labyrinths in all—classical, solid, ripple, and more—in one great volume. Perfect inexpensive puzzler for clever youngsters. Full solutions. 112pp. 8⅛ x 11. 0-486-22951-3

PIANO TUNING, J. Cree Fischer. Clearest, best book for beginner, amateur. Simple repairs, raising dropped notes, tuning by easy method of flattened fifths. No previous skills needed. 4 illustrations. 201pp. 5⅜ x 8½. 0-486-23267-0

HINTS TO SINGERS, Lillian Nordica. Selecting the right teacher, developing confidence, overcoming stage fright, and many other important skills receive thoughtful discussion in this indispensible guide, written by a world-famous diva of four decades' experience. 96pp. 5⅜ x 8½. 0-486-40094-8

THE COMPLETE NONSENSE OF EDWARD LEAR, Edward Lear. All nonsense limericks, zany alphabets, Owl and Pussycat, songs, nonsense botany, etc., illustrated by Lear. Total of 320pp. 5⅜ x 8½. (Available in U.S. only.) 0-486-20167-8

VICTORIAN PARLOUR POETRY: An Annotated Anthology, Michael R. Turner. 117 gems by Longfellow, Tennyson, Browning, many lesser-known poets. "The Village Blacksmith," "Curfew Must Not Ring Tonight," "Only a Baby Small," dozens more, often difficult to find elsewhere. Index of poets, titles, first lines. xxiii + 325pp. 5⅜ x 8¼. 0-486-27044-0

DUBLINERS, James Joyce. Fifteen stories offer vivid, tightly focused observations of the lives of Dublin's poorer classes. At least one, "The Dead," is considered a masterpiece. Reprinted complete and unabridged from standard edition. 160pp. 5³⁄₁₆ x 8¼. 0-486-26870-5

GREAT WEIRD TALES: 14 Stories by Lovecraft, Blackwood, Machen and Others, S. T. Joshi (ed.). 14 spellbinding tales, including "The Sin Eater," by Fiona McLeod, "The Eye Above the Mantel," by Frank Belknap Long, as well as renowned works by R. H. Barlow, Lord Dunsany, Arthur Machen, W. C. Morrow and eight other masters of the genre. 256pp. 5⅜ x 8½. (Available in U.S. only.) 0-486-40436-6

THE BOOK OF THE SACRED MAGIC OF ABRAMELIN THE MAGE, translated by S. MacGregor Mathers. Medieval manuscript of ceremonial magic. Basic document in Aleister Crowley, Golden Dawn groups. 268pp. 5⅜ x 8½.

0-486-23211-5

THE BATTLES THAT CHANGED HISTORY, Fletcher Pratt. Eminent historian profiles 16 crucial conflicts, ancient to modern, that changed the course of civilization. 352pp. 5⅜ x 8½. 0-486-41129-X

NEW RUSSIAN-ENGLISH AND ENGLISH-RUSSIAN DICTIONARY, M. A. O'Brien. This is a remarkably handy Russian dictionary, containing a surprising amount of information, including over 70,000 entries. 366pp. 4½ x 6⅛.

0-486-20208-9

NEW YORK IN THE FORTIES, Andreas Feininger. 162 brilliant photographs by the well-known photographer, formerly with *Life* magazine. Commuters, shoppers, Times Square at night, much else from city at its peak. Captions by John von Hartz. 181pp. 9¼ x 10¾. 0-486-23585-8

INDIAN SIGN LANGUAGE, William Tomkins. Over 525 signs developed by Sioux and other tribes. Written instructions and diagrams. Also 290 pictographs. 111pp. 6⅛ x 9¼. 0-486-22029-X

ANATOMY: A Complete Guide for Artists, Joseph Sheppard. A master of figure drawing shows artists how to render human anatomy convincingly. Over 460 illustrations. 224pp. 8⅜ x 11¼. 0-486-27279-6

MEDIEVAL CALLIGRAPHY: Its History and Technique, Marc Drogin. Spirited history, comprehensive instruction manual covers 13 styles (ca. 4th century through 15th). Excellent photographs; directions for duplicating medieval techniques with modern tools. 224pp. 8⅛ x 11¼. 0-486-26142-5

DRIED FLOWERS: How to Prepare Them, Sarah Whitlock and Martha Rankin. Complete instructions on how to use silica gel, meal and borax, perlite aggregate, sand and borax, glycerine and water to create attractive permanent flower arrangements. 12 illustrations. 32pp. 5⅜ x 8½. 0-486-21802-3

EASY-TO-MAKE BIRD FEEDERS FOR WOODWORKERS, Scott D. Campbell. Detailed, simple-to-use guide for designing, constructing, caring for and using feeders. Text, illustrations for 12 classic and contemporary designs. 96pp. 5⅜ x 8½. 0-486-25847-5

THE COMPLETE BOOK OF BIRDHOUSE CONSTRUCTION FOR WOOD-WORKERS, Scott D. Campbell. Detailed instructions, illustrations, tables. Also data on bird habitat and instinct patterns. Bibliography. 3 tables. 63 illustrations in 15 figures. 48pp. 5¼ x 8½. 0-486-24407-5

SCOTTISH WONDER TALES FROM MYTH AND LEGEND, Donald A. Mackenzie. 16 lively tales tell of giants rumbling down mountainsides, of a magic wand that turns stone pillars into warriors, of gods and goddesses, evil hags, powerful forces and more. 240pp. 5⅜ x 8½. 0-486-29677-6

THE HISTORY OF UNDERCLOTHES, C. Willett Cunnington and Phyllis Cunnington. Fascinating, well-documented survey covering six centuries of English undergarments, enhanced with over 100 illustrations: 12th-century laced-up bodice, footed long drawers (1795), 19th-century bustles, l9th-century corsets for men, Victorian "bust improvers," much more. 272pp. 5⅜ x 8¼. 0-486-27124-2

ARTS AND CRAFTS FURNITURE: The Complete Brooks Catalog of 1912, Brooks Manufacturing Co. Photos and detailed descriptions of more than 150 now very collectible furniture designs from the Arts and Crafts movement depict davenports, settees, buffets, desks, tables, chairs, bedsteads, dressers and more, all built of solid, quarter-sawed oak. Invaluable for students and enthusiasts of antiques, Americana and the decorative arts. 80pp. 6½ x 9¼. 0-486-27471-3

WILBUR AND ORVILLE: A Biography of the Wright Brothers, Fred Howard. Definitive, crisply written study tells the full story of the brothers' lives and work. A vividly written biography, unparalleled in scope and color, that also captures the spirit of an extraordinary era. 560pp. 6⅛ x 9¼. 0-486-40297-5

THE ARTS OF THE SAILOR: Knotting, Splicing and Ropework, Hervey Garrett Smith. Indispensable shipboard reference covers tools, basic knots and useful hitches; handsewing and canvas work, more. Over 100 illustrations. Delightful reading for sea lovers. 256pp. 5⅜ x 8½. 0-486-26440-8

FRANK LLOYD WRIGHT'S FALLINGWATER: The House and Its History, Second, Revised Edition, Donald Hoffmann. A total revision—both in text and illustrations—of the standard document on Fallingwater, the boldest, most personal architectural statement of Wright's mature years, updated with valuable new material from the recently opened Frank Lloyd Wright Archives. "Fascinating"–*The New York Times.* 116 illustrations. 128pp. 9¼ x 10¾. 0-486-27430-6

PHOTOGRAPHIC SKETCHBOOK OF THE CIVIL WAR, Alexander Gardner. 100 photos taken on field during the Civil War. Famous shots of Manassas Harper's Ferry, Lincoln, Richmond, slave pens, etc. 244pp. 10⅝ x 8¼. 0-486-22731-6

FIVE ACRES AND INDEPENDENCE, Maurice G. Kains. Great back-to-the-land classic explains basics of self-sufficient farming. The one book to get. 95 illustrations. 397pp. 5⅜ x 8½. 0-486-20974-1

A MODERN HERBAL, Margaret Grieve. Much the fullest, most exact, most useful compilation of herbal material. Gigantic alphabetical encyclopedia, from aconite to zedoary, gives botanical information, medical properties, folklore, economic uses, much else. Indispensable to serious reader. 161 illustrations. 888pp. 6½ x 9¼. 2-vol. set. (Available in U.S. only.) Vol. I: 0-486-22798-7 Vol. II: 0-486-22799-5

HIDDEN TREASURE MAZE BOOK, Dave Phillips. Solve 34 challenging mazes accompanied by heroic tales of adventure. Evil dragons, people-eating plants, blood-thirsty giants, many more dangerous adversaries lurk at every twist and turn. 34 mazes, stories, solutions. 48pp. 8¼ x 11. 0-486-24566-7

LETTERS OF W. A. MOZART, Wolfgang A. Mozart. Remarkable letters show bawdy wit, humor, imagination, musical insights, contemporary musical world; includes some letters from Leopold Mozart. 276pp. 5⅜ x 8½. 0-486-22859-2

BASIC PRINCIPLES OF CLASSICAL BALLET, Agrippina Vaganova. Great Russian theoretician, teacher explains methods for teaching classical ballet. 118 illustrations. 175pp. 5⅜ x 8½. 0-486-22036-2

THE JUMPING FROG, Mark Twain. Revenge edition. The original story of The Celebrated Jumping Frog of Calaveras County, a hapless French translation, and Twain's hilarious "retranslation" from the French. 12 illustrations. 66pp. 5⅜ x 8½.
0-486-22686-7

BEST REMEMBERED POEMS, Martin Gardner (ed.). The 126 poems in this superb collection of 19th- and 20th-century British and American verse range from Shelley's "To a Skylark" to the impassioned "Renascence" of Edna St. Vincent Millay and to Edward Lear's whimsical "The Owl and the Pussycat." 224pp. 5⅜ x 8½.
0-486-27165-X

COMPLETE SONNETS, William Shakespeare. Over 150 exquisite poems deal with love, friendship, the tyranny of time, beauty's evanescence, death and other themes in language of remarkable power, precision and beauty. Glossary of archaic terms. 80pp. 5³⁄₁₆ x 8¼. 0-486-26686-9

HISTORIC HOMES OF THE AMERICAN PRESIDENTS, Second, Revised Edition, Irvin Haas. A traveler's guide to American Presidential homes, most open to the public, depicting and describing homes occupied by every American President from George Washington to George Bush. With visiting hours, admission charges, travel routes. 175 photographs. Index. 160pp. 8¼ x 11. 0-486-26751-2

THE WIT AND HUMOR OF OSCAR WILDE, Alvin Redman (ed.). More than 1,000 ripostes, paradoxes, wisecracks: Work is the curse of the drinking classes; I can resist everything except temptation; etc. 258pp. 5⅜ x 8½. 0-486-20602-5

SHAKESPEARE LEXICON AND QUOTATION DICTIONARY, Alexander Schmidt. Full definitions, locations, shades of meaning in every word in plays and poems. More than 50,000 exact quotations. 1,485pp. 6½ x 9¼. 2-vol. set.
Vol. 1: 0-486-22726-X Vol. 2: 0-486-22727-8

SELECTED POEMS, Emily Dickinson. Over 100 best-known, best-loved poems by one of America's foremost poets, reprinted from authoritative early editions. No comparable edition at this price. Index of first lines. 64pp. 5³⁄₁₆ x 8¼. 0-486-26466-1

THE INSIDIOUS DR. FU-MANCHU, Sax Rohmer. The first of the popular mystery series introduces a pair of English detectives to their archnemesis, the diabolical Dr. Fu-Manchu. Flavorful atmosphere, fast-paced action, and colorful characters enliven this classic of the genre. 208pp. 5³⁄₁₆ x 8¼. 0-486-29898-1

THE MALLEUS MALEFICARUM OF KRAMER AND SPRENGER, translated by Montague Summers. Full text of most important witchhunter's "bible," used by both Catholics and Protestants. 278pp. 6⅝ x 10. 0-486-22802-9

SPANISH STORIES/CUENTOS ESPAÑOLES: A Dual-Language Book, Angel Flores (ed.). Unique format offers 13 great stories in Spanish by Cervantes, Borges, others. Faithful English translations on facing pages. 352pp. 5⅜ x 8½.
0-486-25399-6

GARDEN CITY, LONG ISLAND, IN EARLY PHOTOGRAPHS, 1869–1919, Mildred H. Smith. Handsome treasury of 118 vintage pictures, accompanied by carefully researched captions, document the Garden City Hotel fire (1899), the Vanderbilt Cup Race (1908), the first airmail flight departing from the Nassau Boulevard Aerodrome (1911), and much more. 96pp. 8⅞ x 11¾. 0-486-40669-5

OLD QUEENS, N.Y., IN EARLY PHOTOGRAPHS, Vincent F. Seyfried and William Asadorian. Over 160 rare photographs of Maspeth, Jamaica, Jackson Heights, and other areas. Vintage views of DeWitt Clinton mansion, 1939 World's Fair and more. Captions. 192pp. 8⅞ x 11. 0-486-26358-4

CAPTURED BY THE INDIANS: 15 Firsthand Accounts, 1750-1870, Frederick Drimmer. Astounding true historical accounts of grisly torture, bloody conflicts, relentless pursuits, miraculous escapes and more, by people who lived to tell the tale. 384pp. 5⅜ x 8½. 0-486-24901-8

THE WORLD'S GREAT SPEECHES (Fourth Enlarged Edition), Lewis Copeland, Lawrence W. Lamm, and Stephen J. McKenna. Nearly 300 speeches provide public speakers with a wealth of updated quotes and inspiration–from Pericles' funeral oration and William Jennings Bryan's "Cross of Gold Speech" to Malcolm X's powerful words on the Black Revolution and Earl of Spenser's tribute to his sister, Diana, Princess of Wales. 944pp. 5⅜ x 8⅜. 0-486-40903-1

THE BOOK OF THE SWORD, Sir Richard F. Burton. Great Victorian scholar/adventurer's eloquent, erudite history of the "queen of weapons"–from prehistory to early Roman Empire. Evolution and development of early swords, variations (sabre, broadsword, cutlass, scimitar, etc.), much more. 336pp. 6⅛ x 9¼.
0-486-25434-8

AUTOBIOGRAPHY: The Story of My Experiments with Truth, Mohandas K. Gandhi. Boyhood, legal studies, purification, the growth of the Satyagraha (nonviolent protest) movement. Critical, inspiring work of the man responsible for the freedom of India. 480pp. 5⅜ x 8½. (Available in U.S. only.) 0-486-24593-4

CELTIC MYTHS AND LEGENDS, T. W. Rolleston. Masterful retelling of Irish and Welsh stories and tales. Cuchulain, King Arthur, Deirdre, the Grail, many more. First paperback edition. 58 full-page illustrations. 512pp. 5⅜ x 8½. 0-486-26507-2

THE PRINCIPLES OF PSYCHOLOGY, William James. Famous long course complete, unabridged. Stream of thought, time perception, memory, experimental methods; great work decades ahead of its time. 94 figures. 1,391pp. 5⅜ x 8½. 2-vol. set.
Vol. I: 0-486-20381-6 Vol. II: 0-486-20382-4

THE WORLD AS WILL AND REPRESENTATION, Arthur Schopenhauer. Definitive English translation of Schopenhauer's life work, correcting more than 1,000 errors, omissions in earlier translations. Translated by E. F. J. Payne. Total of 1,269pp. 5⅜ x 8½. 2-vol. set. Vol. 1: 0-486-21761-2 Vol. 2: 0-486-21762-0

MAGIC AND MYSTERY IN TIBET, Madame Alexandra David-Neel. Experiences among lamas, magicians, sages, sorcerers, Bonpa wizards. A true psychic discovery. 32 illustrations. 321pp. 5⅜ x 8½. (Available in U.S. only.) 0-486-22682-4

THE EGYPTIAN BOOK OF THE DEAD, E. A. Wallis Budge. Complete reproduction of Ani's papyrus, finest ever found. Full hieroglyphic text, interlinear transliteration, word-for-word translation, smooth translation. 533pp. 6½ x 9¼.

0-486-21866-X

HISTORIC COSTUME IN PICTURES, Braun & Schneider. Over 1,450 costumed figures in clearly detailed engravings–from dawn of civilization to end of 19th century. Captions. Many folk costumes. 256pp. 8⅜ x 11¼. 0-486-23150-X

MATHEMATICS FOR THE NONMATHEMATICIAN, Morris Kline. Detailed, college-level treatment of mathematics in cultural and historical context, with numerous exercises. Recommended Reading Lists. Tables. Numerous figures. 641pp. 5⅜ x 8½.

0-486-24823-2

PROBABILISTIC METHODS IN THE THEORY OF STRUCTURES, Isaac Elishakoff. Well-written introduction covers the elements of the theory of probability from two or more random variables, the reliability of such multivariable structures, the theory of random function, Monte Carlo methods of treating problems incapable of exact solution, and more. Examples. 502pp. 5⅜ x 8½. 0-486-40691-1

THE RIME OF THE ANCIENT MARINER, Gustave Doré, S. T. Coleridge. Doré's finest work; 34 plates capture moods, subtleties of poem. Flawless full-size reproductions printed on facing pages with authoritative text of poem. "Beautiful. Simply beautiful."–*Publisher's Weekly.* 77pp. 9¼ x 12. 0-486-22305-1

SCULPTURE: Principles and Practice, Louis Slobodkin. Step-by-step approach to clay, plaster, metals, stone; classical and modern. 253 drawings, photos. 255pp. 8⅛ x 11.

0-486-22960-2

THE INFLUENCE OF SEA POWER UPON HISTORY, 1660–1783, A. T. Mahan. Influential classic of naval history and tactics still used as text in war colleges. First paperback edition. 4 maps. 24 battle plans. 640pp. 5⅜ x 8½. 0-486-25509-3

THE STORY OF THE TITANIC AS TOLD BY ITS SURVIVORS, Jack Winocour (ed.). What it was really like. Panic, despair, shocking inefficiency, and a little heroism. More thrilling than any fictional account. 26 illustrations. 320pp. 5⅜ x 8½.

0-486-20610-6

ONE TWO THREE . . . INFINITY: Facts and Speculations of Science, George Gamow. Great physicist's fascinating, readable overview of contemporary science: number theory, relativity, fourth dimension, entropy, genes, atomic structure, much more. 128 illustrations. Index. 352pp. 5⅜ x 8½. 0-486-25664-2

DALÍ ON MODERN ART: The Cuckolds of Antiquated Modern Art, Salvador Dalí. Influential painter skewers modern art and its practitioners. Outrageous evaluations of Picasso, Cézanne, Turner, more. 15 renderings of paintings discussed. 44 calligraphic decorations by Dalí. 96pp. 5⅜ x 8½. (Available in U.S. only.) 0-486-29220-7

ANTIQUE PLAYING CARDS: A Pictorial History, Henry René D'Allemagne. Over 900 elaborate, decorative images from rare playing cards (14th–20th centuries): Bacchus, death, dancing dogs, hunting scenes, royal coats of arms, players cheating, much more. 96pp. 9¼ x 12¼. 0-486-29265-7

MAKING FURNITURE MASTERPIECES: 30 Projects with Measured Drawings, Franklin H. Gottshall. Step-by-step instructions, illustrations for constructing handsome, useful pieces, among them a Sheraton desk, Chippendale chair, Spanish desk, Queen Anne table and a William and Mary dressing mirror. 224pp. 8⅛ x 11¼.
0-486-29338-6

NORTH AMERICAN INDIAN DESIGNS FOR ARTISTS AND CRAFTSPEOPLE, Eva Wilson. Over 360 authentic copyright-free designs adapted from Navajo blankets, Hopi pottery, Sioux buffalo hides, more. Geometrics, symbolic figures, plant and animal motifs, etc. 128pp. 8⅜ x 11. (Not for sale in the United Kingdom.) 0-486-25341-4

THE FOSSIL BOOK: A Record of Prehistoric Life, Patricia V. Rich et al. Profusely illustrated definitive guide covers everything from single-celled organisms and dinosaurs to birds and mammals and the interplay between climate and man. Over 1,500 illustrations. 760pp. 7½ x 10⅛. 0-486-29371-8

VICTORIAN ARCHITECTURAL DETAILS: Designs for Over 700 Stairs, Mantels, Doors, Windows, Cornices, Porches, and Other Decorative Elements, A. J. Bicknell & Company. Everything from dormer windows and piazzas to balconies and gable ornaments. Also includes elevations and floor plans for handsome, private residences and commercial structures. 80pp. 9⅜ x 12¼. 0-486-44015-X

WESTERN ISLAMIC ARCHITECTURE: A Concise Introduction, John D. Hoag. Profusely illustrated critical appraisal compares and contrasts Islamic mosques and palaces—from Spain and Egypt to other areas in the Middle East. 139 illustrations. 128pp. 6 x 9. 0-486-43760-4

CHINESE ARCHITECTURE: A Pictorial History, Liang Ssu-ch'eng. More than 240 rare photographs and drawings depict temples, pagodas, tombs, bridges, and imperial palaces comprising much of China's architectural heritage. 152 halftones, 94 diagrams. 232pp. 10¾ x 9⅞. 0-486-43999-2

THE RENAISSANCE: Studies in Art and Poetry, Walter Pater. One of the most talked-about books of the 19th century, *The Renaissance* combines scholarship and philosophy in an innovative work of cultural criticism that examines the achievements of Botticelli, Leonardo, Michelangelo, and other artists. "The holy writ of beauty."–Oscar Wilde. 160pp. 5⅜ x 8½. 0-486-44025-7

A TREATISE ON PAINTING, Leonardo da Vinci. The great Renaissance artist's practical advice on drawing and painting techniques covers anatomy, perspective, composition, light and shadow, and color. A classic of art instruction, it features 48 drawings by Nicholas Poussin and Leon Battista Alberti. 192pp. 5⅜ x 8½.
0-486-44155-5

THE MIND OF LEONARDO DA VINCI, Edward McCurdy. More than just a biography, this classic study by a distinguished historian draws upon Leonardo's extensive writings to offer numerous demonstrations of the Renaissance master's achievements, not only in sculpture and painting, but also in music, engineering, and even experimental aviation. 384pp. 5⅜ x 8½. 0-486-44142-3

WASHINGTON IRVING'S RIP VAN WINKLE, Illustrated by Arthur Rackham. Lovely prints that established artist as a leading illustrator of the time and forever etched into the popular imagination a classic of Catskill lore. 51 full-color plates. 80pp. 8⅜ x 11. 0-486-44242-X

HENSCHE ON PAINTING, John W. Robichaux. Basic painting philosophy and methodology of a great teacher, as expounded in his famous classes and workshops on Cape Cod. 7 illustrations in color on covers. 80pp. 5⅜ x 8½. 0-486-43728-0

LIGHT AND SHADE: A Classic Approach to Three-Dimensional Drawing, Mrs. Mary P. Merrifield. Handy reference clearly demonstrates principles of light and shade by revealing effects of common daylight, sunshine, and candle or artificial light on geometrical solids. 13 plates. 64pp. 5⅜ x 8½. 0-486-44143-1

ASTROLOGY AND ASTRONOMY: A Pictorial Archive of Signs and Symbols, Ernst and Johanna Lehner. Treasure trove of stories, lore, and myth, accompanied by more than 300 rare illustrations of planets, the Milky Way, signs of the zodiac, comets, meteors, and other astronomical phenomena. 192pp. 8⅜ x 11.
0-486-43981-X

JEWELRY MAKING: Techniques for Metal, Tim McCreight. Easy-to-follow instructions and carefully executed illustrations describe tools and techniques, use of gems and enamels, wire inlay, casting, and other topics. 72 line illustrations and diagrams. 176pp. 8¼ x 10⅞. 0-486-44043-5

MAKING BIRDHOUSES: Easy and Advanced Projects, Gladstone Califf. Easy-to-follow instructions include diagrams for everything from a one-room house for bluebirds to a forty-two-room structure for purple martins. 56 plates; 4 figures. 80pp. 8¾ x 6⅝. 0-486-44183-0

LITTLE BOOK OF LOG CABINS: How to Build and Furnish Them, William S. Wicks. Handy how-to manual, with instructions and illustrations for building cabins in the Adirondack style, fireplaces, stairways, furniture, beamed ceilings, and more. 102 line drawings. 96pp. 8¾ x 6⅝. 0-486-44259-4

THE SEASONS OF AMERICA PAST, Eric Sloane. From "sugaring time" and strawberry picking to Indian summer and fall harvest, a whole year's activities described in charming prose and enhanced with 79 of the author's own illustrations. 160pp. 8¼ x 11. 0-486-44220-9

THE METROPOLIS OF TOMORROW, Hugh Ferriss. Generous, prophetic vision of the metropolis of the future, as perceived in 1929. Powerful illustrations of towering structures, wide avenues, and rooftop parks—all features in many of today's modern cities. 59 illustrations. 144pp. 8¼ x 11. 0-486-43727-2

THE PATH TO ROME, Hilaire Belloc. This 1902 memoir abounds in lively vignettes from a vanished time, recounting a pilgrimage on foot across the Alps and Apennines in order to "see all Europe which the Christian Faith has saved." 77 of the author's original line drawings complement his sparkling prose. 272pp. 5⅜ x 8½.
0-486-44001-X

THE HISTORY OF RASSELAS: Prince of Abissinia, Samuel Johnson. Distinguished English writer attacks eighteenth-century optimism and man's unrealistic estimates of what life has to offer. 112pp. 5⅜ x 8½. 0-486-44094-X

A VOYAGE TO ARCTURUS, David Lindsay. A brilliant flight of pure fancy, where wild creatures crowd the fantastic landscape and demented torturers dominate victims with their bizarre mental powers. 272pp. 5⅜ x 8½. 0-486-44198-9

Paperbound unless otherwise indicated. Available at your book dealer, online at **www.doverpublications.com**, or by writing to Dept. GI, Dover Publications, Inc., 31 East 2nd Street, Mineola, NY 11501. For current price information or for free catalogs (please indicate field of interest), write to Dover Publications or log on to **www.doverpublications.com** and see every Dover book in print. Dover publishes more than 500 books each year on science, elementary and advanced mathematics, biology, music, art, literary history, social sciences, and other areas.